# ORIGINS

The Creative Spark Behind Japan's Best Product Designs

# ORIGINS

## The Creative Spark Behind Japan's Best Product Designs

### SHU HAGIWARA

PHOTOGRAPHY BY Masashi Kuma

TRANSLATED BY Philip Price

KODANSHA INTERNATIONAL
Tokyo • New York • London

Distributed in the United States by Kodansha America Inc., and in the
United Kingdom and continental Europe by Kodansha Europe Ltd.

Published by Kodansha International, Ltd., 17–14 Otowa 1-chome,
Bunkyo-ku, Tokyo 112–8652, and Kodansha America, Inc.

Copyright © 2006 Shu Hagiwara.
Photographs © 2006 Masashi Kuma.
English Translation © 2006 Kodansha International Ltd.
ISBN 978-4-7700-3040-5

First Edition, 2006
15 14 13 12 11 10 09 08 07 06    10 9 8 7 6 5 4 3 2 1

Library of Congress Cataloging-in-Publication Data available

www.kodansha-intl.com

# Contents

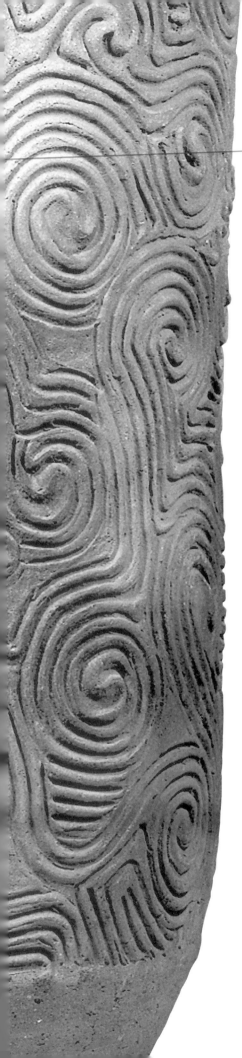

The celebrated designer Sori Yanagi has always stated his belief in striving for the beauty of "anonymous design." Anonymously designed products are never over designed or too commercially conscious, a concept that is illustrated in this piece of ancient Jomon-era pottery (13,000–300 B.C.). Of course, no one knows the name or identity of the artisan, yet the innocent beauty of his functional work transcends the centuries.

# Introduction

## A turning point for Japanese product design

From 1993 to 2004, I worked for Living Design Center Ozone, a company that provides information relating to interior design. By the time of my tenure, the astonishing postwar growth of the Japanese economy had reached saturation point, and with the spectacular bursting of the bubble economy, many Japanese people were beginning to turn their attention away from material wealth toward more spiritual concerns. It was a period of great confusion for Japan as old certainties gave way to new questions about how to realize a global, sustainable society, how to respond to the dramatic technological leaps that had given us the Internet and our cell phones, and how to deal with the demographic changes in our increasingly graying, increasingly childless country.

Years earlier, during the lean postwar years of recovery, Japanese product design had taken off in earnest, spearheaded by freelance designers such as Riki Watanabe and Sori Yanagi. Returning from a study visit to America in 1951, Konosuke Matsushita, the president of Matsushita Electric Industrial Co., declared that the world had entered the era of design, and swiftly set up an in-house design division. His example was followed by many other Japanese manufacturers, and household electrical appliances such as televisions, electric rice cookers, and washing machines began to be designed in huge quantities.

In the 1950s, organizations like the Japan Industrial Designers' Association and the Japan Design Committee were established, and design education programs were begun at schools such as Tokyo National University of Fine Arts & Music, Chiba University, Musashino Art University, Tama Art University, and Kuwasawa Design School. In 1957, the Ministry of International Trade and Industry instituted the Good Design Selection System as part of efforts to promote domestic design.

The 1960s witnessed the creation of masterpieces such as the Butterfly Stool and the Teiza-isu, which garnered high praise overseas and are still in production today. And during the high-speed growth period of the 1970s and the bubble economy of the 1980s—spurred on by the mantra "consumption is a virtue"—new products were released at such a high rate that the whole world seemed to be overflowing with Japanese products. In just a few decades, the country had shifted from a time of grinding poverty to one of extraordinary material wealth.

Surrounded by this clutter of electrical appliances, furniture, tableware, lighting fixtures, cameras, watches, and cars, Japan's design community entered a period of reflection. Designers came to realize that the original essence of their art had been lost in the race to achieve ever-greater sales figures: there was certainly no shortage of *things*, but people were still far from achieving a fulfilling lifestyle.

At the same time, concern for the environment began to grow, and with it an awareness of the importance of recycling. Many people began to look for quality

over quantity, longevity over disposability, craftsmanship over mass production, and were prepared to pay a little more for such goods. Accordingly, designers started to focus more on the personal, creating objects that they themselves would use rather than the generic, bland items of the seventies and eighties. With this shift in focus came a revaluation of the past: traditional Japanese manufacturing techniques were employed once more, and the design masterpieces of the fifties and sixties were reexamined, and in some cases reissued.

Meanwhile, small-scale manufacturers and provincial workshops began to be recognized for their unique vision, individuality, and emphasis on the importance of the design process. As a result of all these changes, the new millennium has given birth to numerous Japanese products that are deeply rooted in the concept of *lifestyle* and reflect the personalities of their designers.

## The origin of an idea

Appreciating the beauty of new products and their long-selling or reissued counterparts from the fifties and sixties leads us naturally to wonder about their origins. In fact, discovering the origin of a product that we use day in and day out gives us the ability to enjoy it all over again.

In Japan, traditions often serve as inspiration. This inspiration may come in the form of a traditional item such as a *tatami* mat, a paper *shoji* screen, an inkstone, or a *furoshiki* wrapping cloth. It may come from the habits and customs that Japanese people have developed over their long history, or it may simply come from the day-to-day living environment of the designer. A design process incorporates many elements. First and foremost are the specifications of the client, closely followed by available materials, manufacturing technology, and issues of distribution and cost. These practicalities do not in themselves constitute the origin of an idea. However, by delving into the life experiences, principles, and ideas of a designer, the origins of that designer's products gradually become clearer.

We can classify the way products originate into categories, and though it's not perfect, it does help us understand what goes into the process.

For example, creating one object using another object as inspiration may appear to be the simplest design method, but it can prove to be unexpectedly difficult. When influences are too obvious, the piece gains an unwanted reputation as a poor imitation. In short, designs only become good designs when they are seen to exhibit a unique presence. A fine example of a product that originated in the shape of another object is Makoto Koizumi's Hamburger Stool. The name of the piece suggests that a hamburger served as a motif, but in fact, Koizumi's inspiration came from a traditional lidded serving dish that he imagined sprouting legs, no less.

The Sumitsubo, by the same designer, was inspired by its namesake, a Japanese carpenter's tool used to mark pieces of timber with ink. In this case, it was the image of a carpenter using his well-worn, much-loved tool, rather than simply the shape of the tool itself, that was projected onto the finished product.

Likewise, Tokujin Yoshioka's ToFU resembles a square block of tofu, and

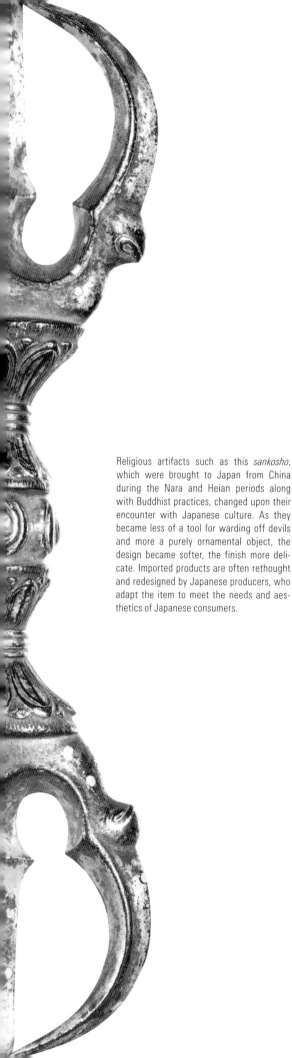

Religious artifacts such as this *sankosho*, which were brought to Japan from China during the Nara and Heian periods along with Buddhist practices, changed upon their encounter with Japanese culture. As they became less of a tool for warding off devils and more a purely ornamental object, the design became softer, the finish more delicate. Imported products are often rethought and redesigned by Japanese producers, who adapt the item to meet the needs and aesthetics of Japanese consumers.

yet the former was named after the production process of the latter, not merely its shape. Finally, Fumie Shibata's Sweets closely resembles a stick of candy, but in texture rather than shape. All of these products are related to their origins in ways that are suggestive, never obvious.

In some other cases, product design begins with the qualities of a new material or the application of pre-existing technology. If so, the potential for creating something completely new is great, but it may be difficult to find a market for the product if the time isn't right. Take the Riki Stool, the material of which was too expensive and too rare for the market when it was designed in the 1960s. Believe it or not, the material was cardboard, and it wasn't until many years later that the stool was revived as a product.

And with Drill Design's Trash Pot, techniques for recycling packaging paper were applied to the creation of a useful trash can, creating a new product from pre-existing technology. New products can also be created by melding materials in unlikely combinations—like the to:ca, which combines a thin wood veneer used in furniture manufacture with an LED more likely to be seen in industrial products.

In a third category, we can place the three-dimensional products that are based on two-dimensional symbols and characters. Take the kimono, for example. By folding and shaping a single piece of cloth around a human body, it is possible to express many things about the wearer. A furoshiki works on a similar foundation, with the human body normally replaced by a lunch box or a gift, and 9 brand take this further by updating the traditional Japanese wrapping cloth for use with a laptop computer.

There are more examples. Shin Nishibori's ring ring takes its inspiration from the three zeros of the year 2000, the year it was designed. The Tottotto by Kazuhiko Tomita, is based on the forks of the letter Y. Other designers have taken a more literal approach to the transformation of two dimensions into three. Naoko Hirota's beautifully simple One Piece Slippers were produced from a single sheet of fabric, while Shiro Kuramata's highly innovative K Series was produced by fashioning a piece of acrylic to make it resemble a sheet of fabric draped over a light fixture. Since one of Japan's most well-known arts is origami, it is perhaps no surprise that Japanese designers have bended and folded their way to many brilliant designs over the years.

Another of the categories in which we can place products' origins is the way people tend to think based on a location: tableware, of course, is designed for use in a kitchen or dining room, while a large television is surely envisaged by the designer in a living room. It sounds obvious, but a more specific location demands that a successful design fill a specific gap or satisfy a certain need. Though many products are based on a universal facet of human behavior and intended for worldwide use, others are geared toward a unique culture or specialist activity.

Examples of objects that have been conceived primarily for Japanese users include rice cookers and rice bowls, while Japan's uniquely complicated shoe etiquette has given birth to various types of indoor footwear and shoehorns. Both were designed with a specific clientele in mind, but it often happens that the product gains unexpected popularity throughout the world.

This ruby Satsuma Kiriko plate, one of a set of three dating from the late Edo Period, is based on European glass-making techniques of the nineteenth century. By the time this plate was made, this style of glass-making had developed through advanced traditional technology into a uniquely Japanese art form that many consider far superior to its Western precursors. Matching high levels of artistry with advanced technological craftsmanship is still a major concern of Japanese product designers.

Perhaps the most famous example of this phenomenon is the Walkman, a global smash hit of the 1980s that continues to sell by the truckload in various updated guises today. And the Supercub motorbike was designed to handle the poor state of Japanese roads following World War II, but became a cult hit among bike lovers overseas. The newest example of a homegrown product that has achieved unforeseen popularity abroad is the Prius hybrid car, which is a must-have item for anyone eager to display their environmental credentials.

Finally, the origin of an idea may be in a simple human emotion. Fumie Shibata's Ken-on-kun electronic thermometer was designed simply to appeal to a sense of motherhood. Products aimed at children have a much greater chance of success if they appeal to a child's sensibilities, as Passkey Design proves with its Animal Rubber Band, which turned unloved, disposable rubber bands into precious possessions. Similarly, Hiroshi Kajimoto transformed a storage stand for cooking tools into the lovable soldier character Boya. Designs such as these, which take feelings into account, offer their users a sense of well-being and satisfaction.

The high intensity blue LED was first commercialized in Japan. Today it can be found in numerous everyday applications such as traffic signals and cellular phones, and has also been welcomed into the world of product design. The to:ca and the Hono in this book are among many contemporary products that owe their existence to the LED.

## Things we can learn from the origins of an idea

In investigating the origins of Japanese products, I hope to offer a glimpse into the aesthetics of the Japanese mind, as well as insight into Japanese attitudes toward creating things, and hitherto unknown aspects of Japanese lifestyles. Although the designers profiled in this book have not limited themselves to their home country and have never fallen into the trap of producing populist Japanesque parodies, there is something unmistakably Japanese in their references, be it a custom or tradition, a production technique, or even the Japanese climate. What seem to be enduring trends in Japanese design include outward simplicity, miniaturization, portability, warmth of texture, and playfulness, all of which are subjected to subtle modification to reflect the concerns and cares of the era.

Those who will continue to plant the seeds of new objects are not only the individual designers themselves, but also the organizations that support the production and distribution infrastructures of our society, the people who support these organizations, and indeed anyone who has specific ideas about the life they wish to lead. The origins of ideas are all around us, sleeping in the backs of minds, but it is a foregone conclusion that one day they will be awoken by the strong will of people who have a desire to create objects that make the world a happier place.

# ORIGINS

## The Creative Spark
## Behind Japan's Best
## Product Designs

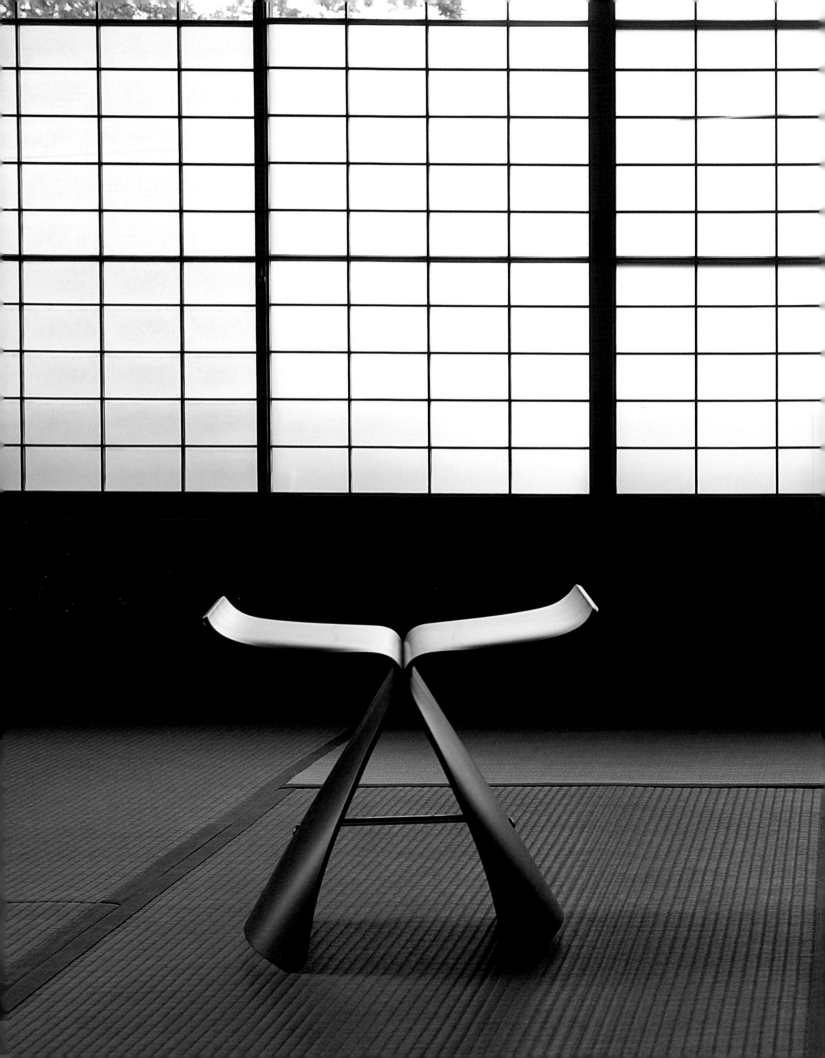

## Flight of Fancy

**The Butterfly Stool**, 1956, Sori Yanagi, plywood (rosewood/maple), W16.5×D12.2×H15.2×SH13.4inches (W42×D31×H38.7×SH34cm), Tendo Co., Ltd.

Unlike its short-lived namesake—whose outstretched wings it resembles—the Butterfly Stool has stood the test of time. It was first produced in 1956, won top prize at the Milan Triennale of 1957, and the following year was acquired by the permanent collection of the New York Museum of Modern Art. It is now housed in countless museums worldwide.

The stool was designed by the renowned industrial designer Sori Yanagi, who in 1956, at the Japanese government's request, took a study tour of the US. He had long been intrigued by the thought of using bent plywood in his designs, and was greatly stimulated into developing his ideas after meeting the designer Charles Eames and seeing his bent plywood chairs.

Yanagi has always been, first and foremost, a designer who thinks with his hands. He creates shapes not by drawing, but by moving his hands to produce models and test pieces over and over until his ideas take shape. He created the Butterfly Stool in this way: over a period of two or three years, he heated vinyl sheets and bent them into various shapes until they acquired his desired form.

Upon showing his finished chair to manufacturers, however, Yanagi found it difficult to raise interest in his piece. Following discussions with the Industrial Art Institute, a national research body then located in the city of Sendai, he planned to manufacture a test piece and put it on sale abroad. The Tendo-mokko Company heard about this and agreed to handle production.

The Butterfly Stool was created by adhering several 0.04 inch-thick veneer sheets together and subjecting the plywood to high-frequency press molding, a method that was then at the cutting edge of manufacturing technology. Two pieces of the molded plywood were then fixed back-to-back by bolts, and the leg portions fastened by a single stay. The simple yet original structure, so strikingly different from contemporary chairs, soon attracted much attention.

Yanagi has always been interested in producing practical furniture and electrical appliances, rather than

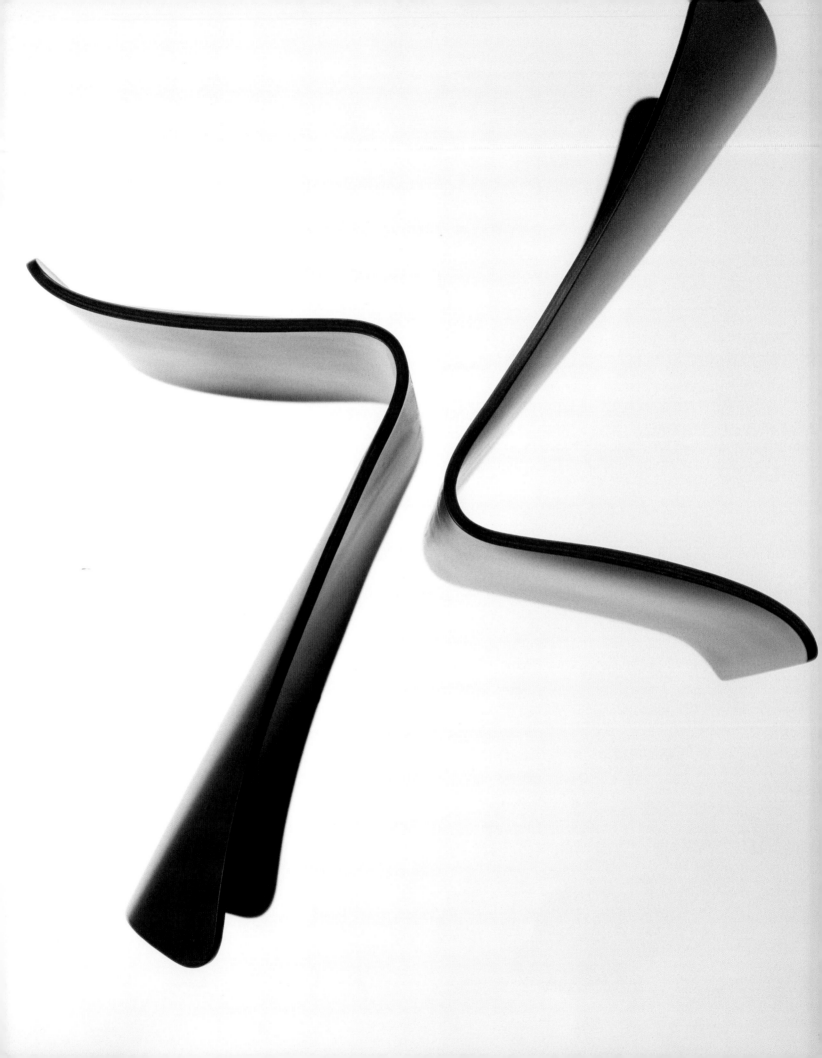

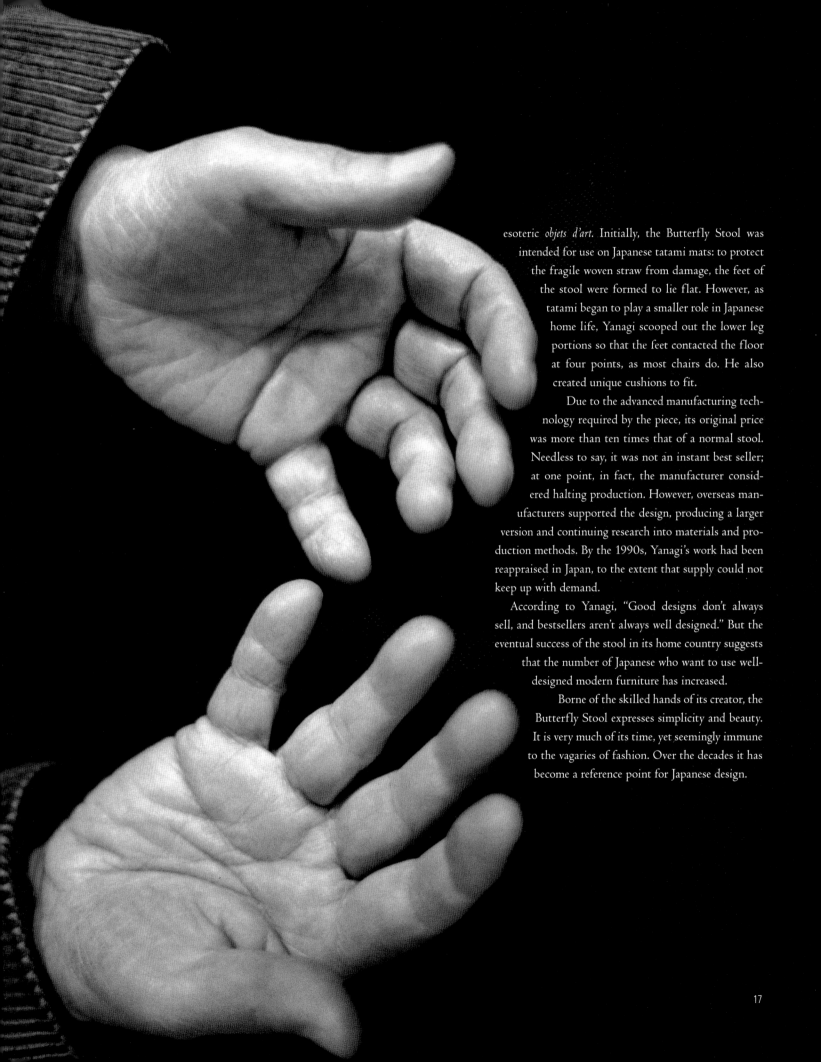

esoteric *objets d'art*. Initially, the Butterfly Stool was intended for use on Japanese tatami mats: to protect the fragile woven straw from damage, the feet of the stool were formed to lie flat. However, as tatami began to play a smaller role in Japanese home life, Yanagi scooped out the lower leg portions so that the feet contacted the floor at four points, as most chairs do. He also created unique cushions to fit.

Due to the advanced manufacturing technology required by the piece, its original price was more than ten times that of a normal stool. Needless to say, it was not an instant best seller; at one point, in fact, the manufacturer considered halting production. However, overseas manufacturers supported the design, producing a larger version and continuing research into materials and production methods. By the 1990s, Yanagi's work had been reappraised in Japan, to the extent that supply could not keep up with demand.

According to Yanagi, "Good designs don't always sell, and bestsellers aren't always well designed." But the eventual success of the stool in its home country suggests that the number of Japanese who want to use well-designed modern furniture has increased.

Borne of the skilled hands of its creator, the Butterfly Stool expresses simplicity and beauty. It is very much of its time, yet seemingly immune to the vagaries of fashion. Over the decades it has become a reference point for Japanese design.

## Sitting on Air

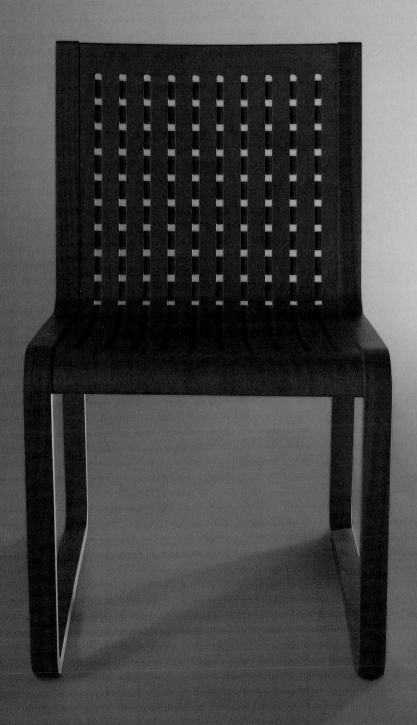

**The Midori Chair**, 2005, Midori Mitsui, laminated wood (beech), W18.3×D21.8×H30.2×SH16.5inches (W46.4×D55.4×H76.8×SH42cm)

Japan is notorious for its hot, humid summers, and designer Midori Mitsui will never forget her daughter's elementary-school days when, after sitting through lessons on a plywood chair, she had to peel herself away to stand up. Conscious of this unpleasant experience, Mitsui designed this ventilated chair, which brings light and breeze into the living space.

She first experimented with woven canvas and rattan, but abandoned these materials due to structural difficulties. After many evenings spent sketching, she hit upon the idea of using a router to create slits in alternate layers of molded plywood, leaving open spaces where they intersected. She produced a full-scale drawing and approached a manufacturer, who deemed it impossible to realize. Undaunted, Mitsui created a 1:5 scale model and submitted the design again, and finally the Midori Chair became a commercial reality.

Latticework doors and bamboo blinds have been a part of Japanese homes for centuries, and the method developed by Mitsui is an extension of this tradition. The materials and processing are more economical than those required for solid, assembled latticework, and the Midori Chair is also thinner, and therefore lighter. The vertical and horizontal slits are spaced precisely to provide comfort, while casting subtle, beautiful shadows. A sense of cool breeziness emanates from the finished product.

While this design is grounded in Japanese sensibilities, Mitsui's horizons extend further. "A home protects its inhabitants from the wind and rain, and yet old Japanese homes were created in harmony with nature," she says. "My designs originate in Tokyo, but I want them to be evaluated and appreciated throughout the world."

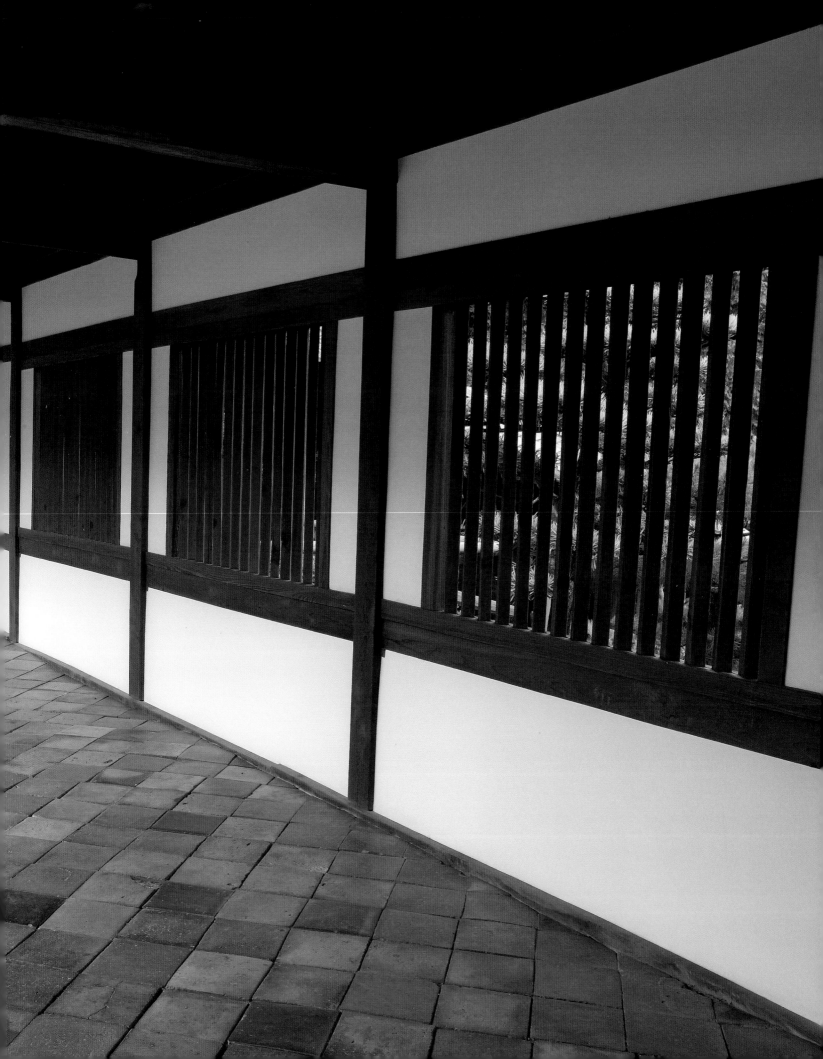

## A Perfect Knit

**Tango Chest 120**, chest, 1997, Hisae Igarashi, maple, 39×47×18 inches (100×120×45cm), Horizumi

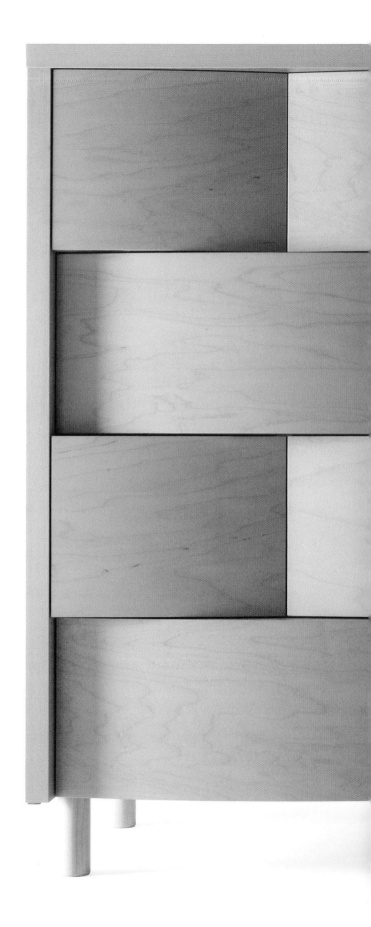

The Japanese have traditionally knitted carved thin slices of wood or bamboo to form fences, frames, and ceilings. Examples of this tradition can still be seen in Kyoto tradesmen's houses and inns. This use of bamboo sheds light on an aspect of Japanese psychology: Rather than creating solid partitions from stone that are physically impossible to penetrate, Japanese sometimes use lightweight, flimsy materials that implicitly prohibit trespassing. Throughout history, these materials have been exploited to create psychological barriers in an endless variety of shapes and patterns.

The Tango chest of drawers reminds us of this tradition. The sheets of maple on the front appear to have been woven. The result, coupled with the Tango's practicality and reasonable price, is a highly attractive piece.

Designer Hisae Igarashi says she was inspired to create Tango by her attraction to regularly recurring forms, such as the repetition of the shoji screens, columns, doors, and beams of traditionally built Japanese houses. "The repetition of straight lines gives me a comforting sense of continuity," she says. "I find many examples of this in my work, yet it's never a conscious decision."

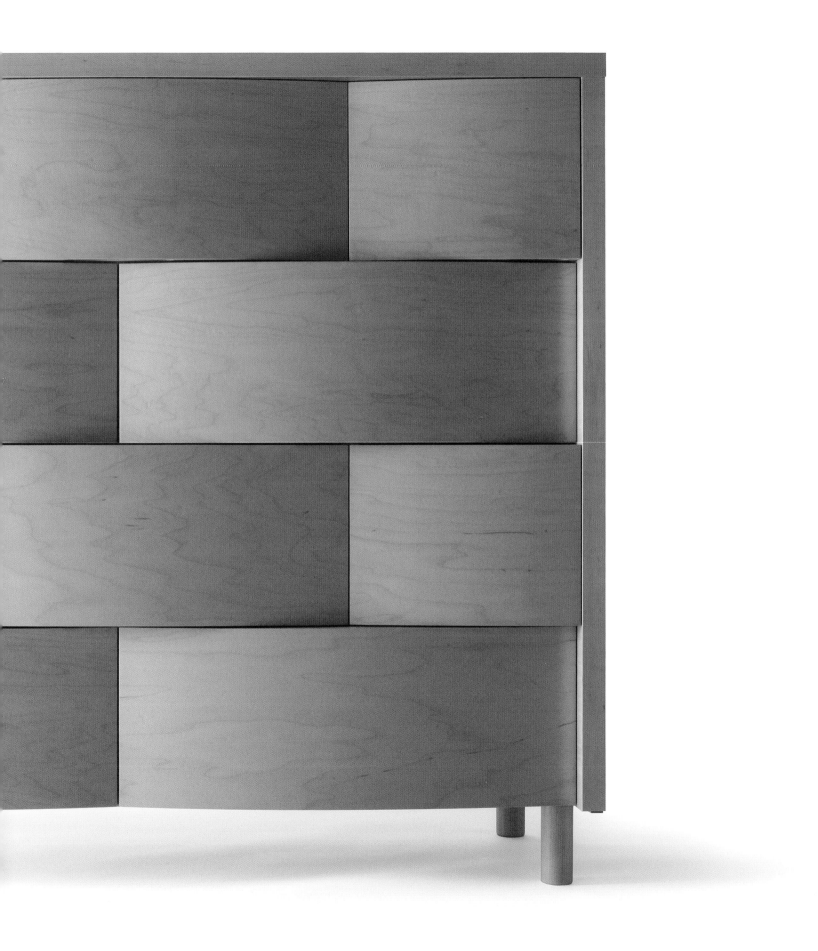

She designed Tango in 1997 as part of an industrial revitalization project sponsored by Shizuoka City. In this project, she worked with four local manufacturers in designing wooden furniture that could be mass-produced for home use, aimed at female buyers. Igarashi's idea of creating chests with no visible handles was developed with one of the local companies called Horizumi Carpentry.

In her other commercial and household designs, Igarashi has often designed pieces without handles, in order to enhance the simplicity and the space in which it is placed. With Tango, she aimed to fuse form and function while cutting costs through the elimination of expensive metal components. To allow the drawers to be opened easily, she applied various measures such as staggering the drawers diagonally. In her final design, the drawers have curved surfaces backed with flexible paulownia wood.

Tango displays simple lines and contrasting surfaces. The subtle curves beat out a rhythm of light and shadow, while the knitted effect of the wood recalls the entwined bodies of two dancers—hence the name of the piece.

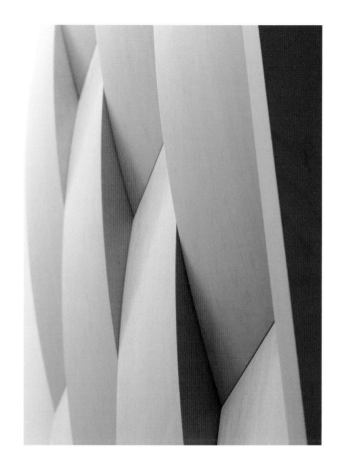

# Light Work

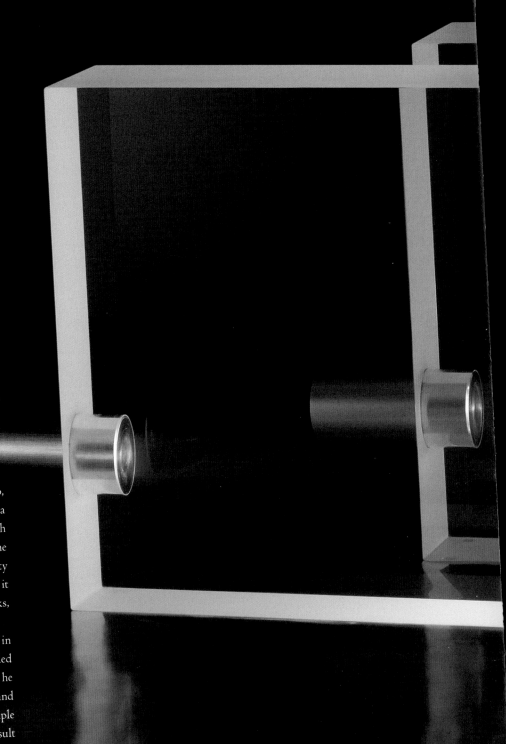

ToFU, lamp, 2000, Tokujin Yoshioka, methacrylate (PMMA)/aluminum, [large type] W14.4×D2.9×H11.6inches (W36.5×D7.6×H29.5 cm), Yamagiwa Corporation

The ToFU is a simple object, comprising little more than a square of acrylic and a small light source, and yet it gives an impression of great luxury and expense. Despite its lack of frills, the lamp exhibits a profundity that proves the point that design is more than simply selecting appropriate materials, colors, and shapes. It is perhaps more fitting to refer to the ToFU as an invention rather than simply a product; such is its originality.

The ToFU lamp is designer Tokujin Yoshioka's first creation to be commercially produced. It is named after a block of bean curd—the foodstuff that Yoshioka thought it resembled.

Yoshioka has always been fascinated by light, often dreaming of using it as a design material. His research led him to fiber optics, where light from a single source is transmitted great distances through narrow acrylic fibers. He envisaged a "block" of light, obtained by reducing the size of the light source and increasing the acrylic portion.

But realizing the concept was far from easy. To do so, he worked with the lighting manufacturer Yamagiwa, a company well known for its design collaborations with both Japanese and overseas creators (indeed, ToFU is the result of a commission from Yamagiwa). The difficulty with ToFU, says Yoshioka, was its austerity. "Basically, it was just too simple," he says. "It didn't have any quirks, any selling points."

Yoshioka credits the dedication of Yamagiwa's staff in seeing the project through. As the technicians struggled to make optical fibers behave according to his design, he noticed the similarities between the emerging object and a block of tofu. It also occurred to him that the simple

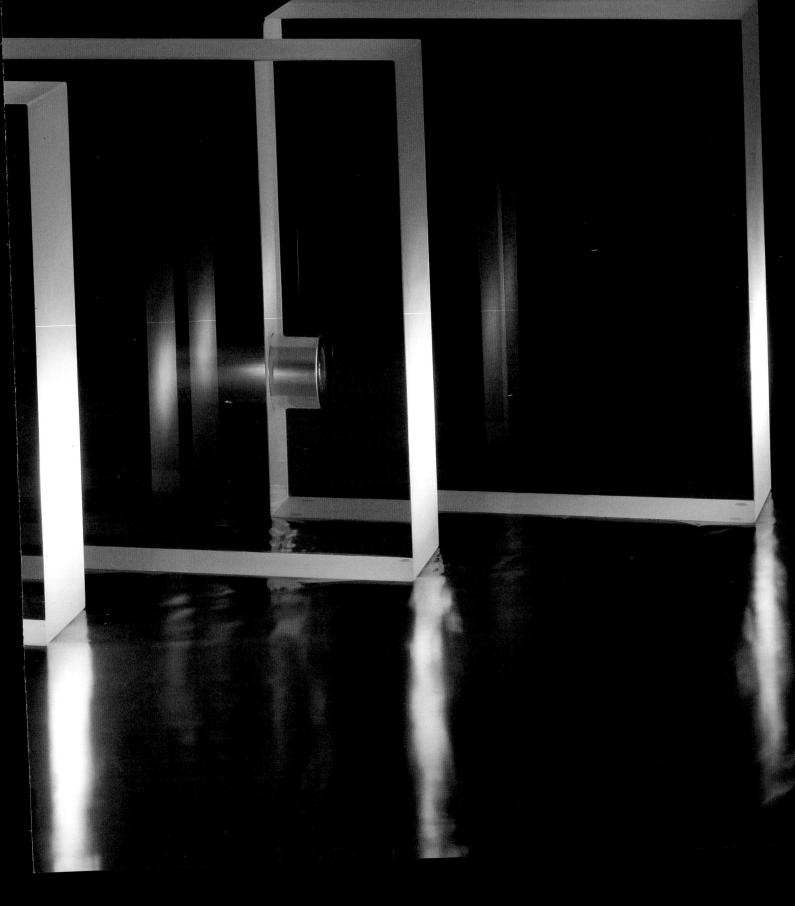

Tofu is made in a process lasting several days, resulting in coagulated lumps of the bean curd, which are then placed in square molds and covered with a heavy stone to press out much of the liquid. Just as the foodstuff is produced using square molds, Yoshioka's light fixture is created by cutting out squares of acrylic.

Yoshioka does not consider himself to be an intrinsically Japanese designer, yet through his work overseas he has become more aware of his Japanese roots and upbringing and of perceptions of Japan abroad. The ToFU lamp has met with international acclaim.

"I think Westerners are more interested in the Japanese way of thinking than they are in Japanese-style objects," he says. "They want to know how our minds work. An object reflects the mind of the person who designed it, so it's terribly important for designers to be true to themselves."

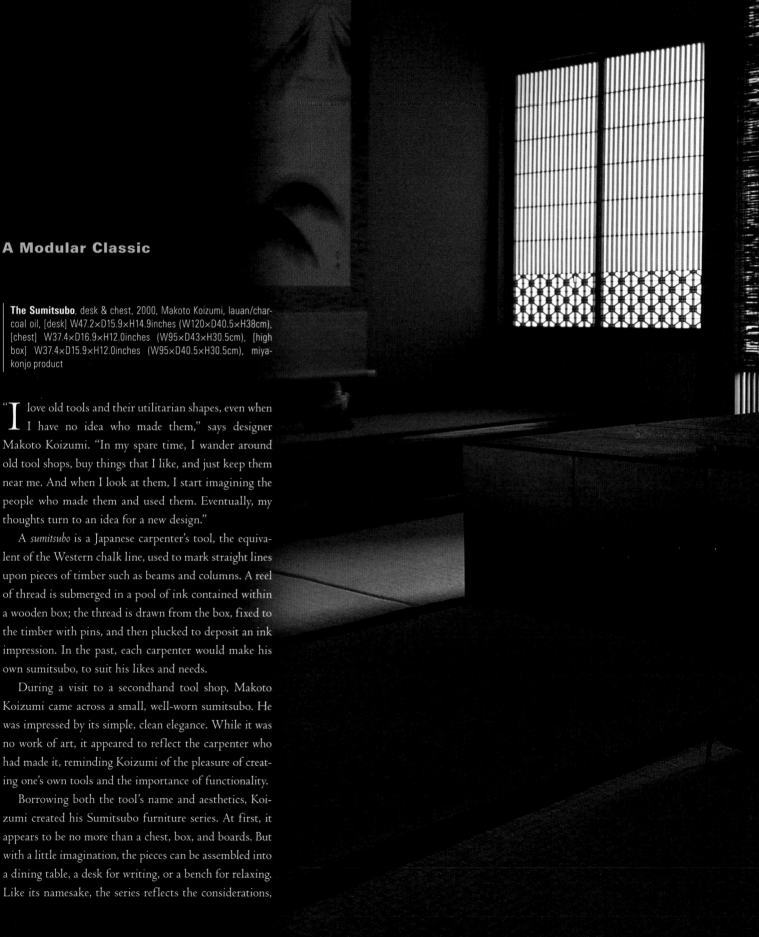

# A Modular Classic

**The Sumitsubo**, desk & chest, 2000, Makoto Koizumi, lauan/charcoal oil, [desk] W47.2×D15.9×H14.9inches (W120×D40.5×H38cm), [chest] W37.4×D16.9×H12.0inches (W95×D43×H30.5cm), [high box] W37.4×D15.9×H12.0inches (W95×D40.5×H30.5cm), miyakonjo product

"I love old tools and their utilitarian shapes, even when I have no idea who made them," says designer Makoto Koizumi. "In my spare time, I wander around old tool shops, buy things that I like, and just keep them near me. And when I look at them, I start imagining the people who made them and used them. Eventually, my thoughts turn to an idea for a new design."

A *sumitsubo* is a Japanese carpenter's tool, the equivalent of the Western chalk line, used to mark straight lines upon pieces of timber such as beams and columns. A reel of thread is submerged in a pool of ink contained within a wooden box; the thread is drawn from the box, fixed to the timber with pins, and then plucked to deposit an ink impression. In the past, each carpenter would make his own sumitsubo, to suit his likes and needs.

During a visit to a secondhand tool shop, Makoto Koizumi came across a small, well-worn sumitsubo. He was impressed by its simple, clean elegance. While it was no work of art, it appeared to reflect the carpenter who had made it, reminding Koizumi of the pleasure of creating one's own tools and the importance of functionality.

Borrowing both the tool's name and aesthetics, Koizumi created his Sumitsubo furniture series. At first, it appears to be no more than a chest, box, and boards. But with a little imagination, the pieces can be assembled into a dining table, a desk for writing, or a bench for relaxing. Like its namesake, the series reflects the considerations,

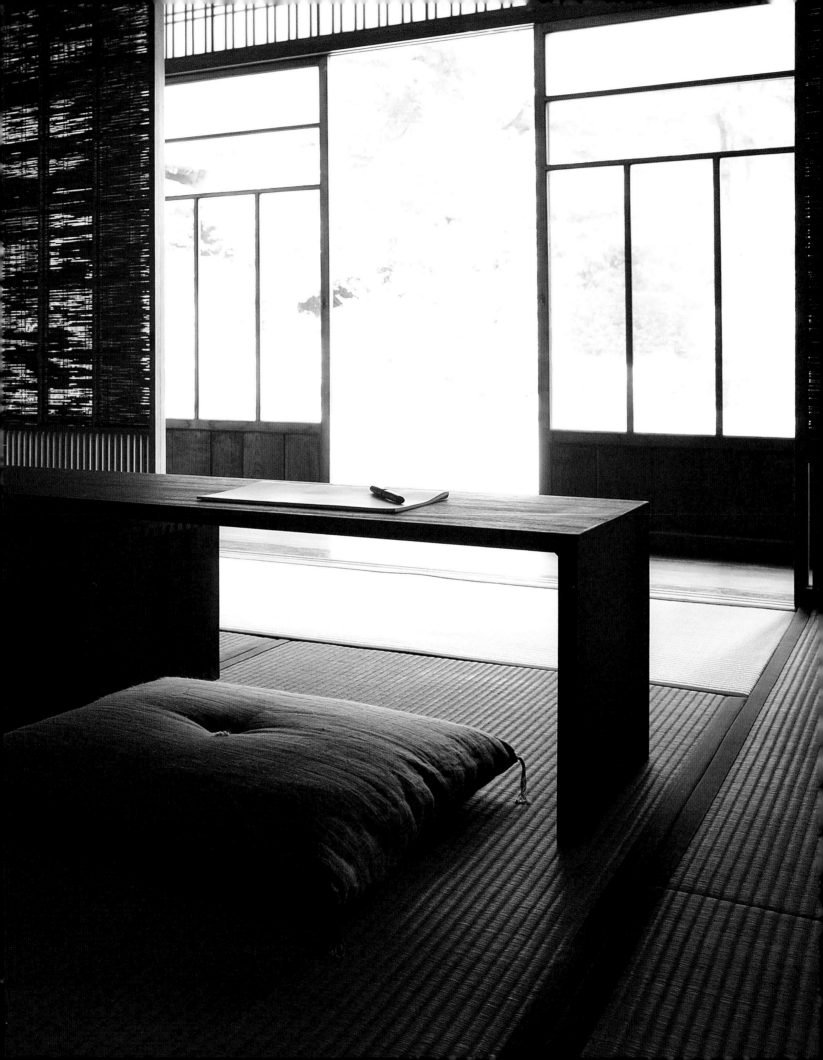

habits, and lifestyle of its user. And since it is designed to optimize floor space, it is intrinsically linked to its country of origin, where much of home life is spent on the floor.

Koizumi is well known for his housing design, in addition to his furniture, and with this piece he incorporates both. Traditionally, the Japanese home is built around a wooden frame, utilizing wood, paper, earth, and grass. It is a healthy structure, that blends with its environment. Tatami rooms contain no permanent furniture—instead, pieces are brought in according to the occasion. With its adaptability and multi-functionality, the Sumitsubo offers great potential for reinvigorating this attractive way of life.

Appropriately, the Sumitsubo is dyed with *sumi*, the Japanese black ink that was originally kept in a sumitsubo. The ink gives an impression of strength and sturdiness and, depending on how the pieces are assembled, can impart the look of a well-worn, much-loved antique—or a stark and modern *objet d'art*. The components are produced by a small manufacturing firm in the city of Miyakonojo on Kyushu island, selected by Koizumi for the quiet confidence and attention to detail of its craftsmen.

Koizumi hopes his creation will become a durable part of its owner's household—acquiring deeper meaning through repeated use.

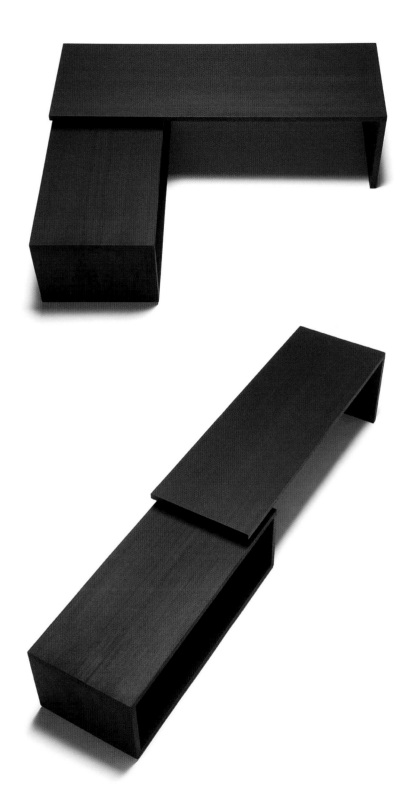

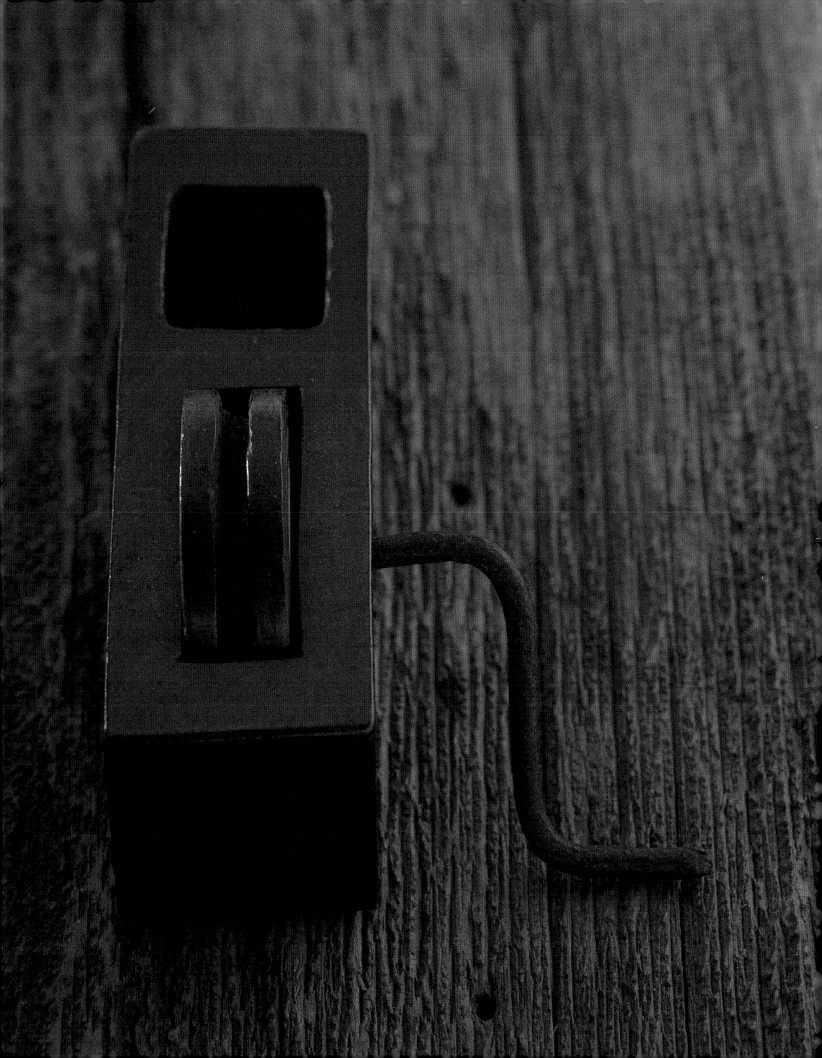

## A Flicker of Love

**METAPHYS/Hono**, electrical candle, 2005, Chiaki Murata, acrylic, Φ0.6×H10.6inches (Φ1.6×H27cm), Silver Seiko Ltd.

This structurally simple product was created in the image of a candle from a hollow acrylic pole painted a soft white, with a light-emitting diode set inside it. By virtue of a hidden control circuit, the LED is sensitive to the slightest wind vibration, so that it flickers like the flame of a candle—or even sputters out. The user can relight the Hono by rubbing an accompanying matchstick-like device lightly against its tip.

In creating the Hono, designer Chiaki Murata gave warmth to the cold, artificial light of an LED. To produce the subtle, delicate colors of a candle flame, he made fine adjustments to the device's optical wavelength and installed a sound controller to create the flickering effect. It is a delightful paradox that these high-tech procedures are concealed within a product that overflows with warmth and humanity.

Murata bases his designs on his observations of human behavior. He says he never intended the Hono to be a practical light, but a product whose sole purpose was to make its viewer feel calm and relaxed. Indeed, the Hono makes life just that little bit richer, bringing a smile to anyone who blows on the acrylic pole and watches the light flicker out.

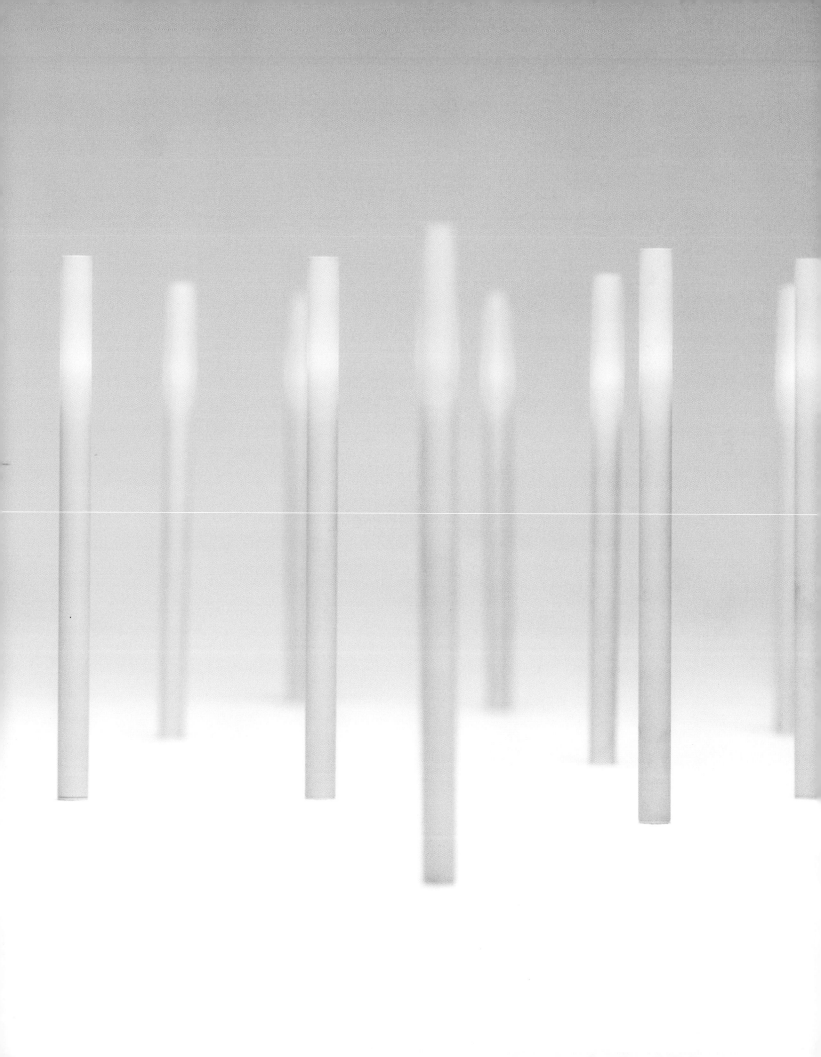

## The Lateral-Thinking Box

**Coro-Hako**, box with wheels, 1994, Katsushi Nagumo, manchurian ash & stainless steel, W77×D19×H18inches (W196×D47×H46cm), Sendai Furniture

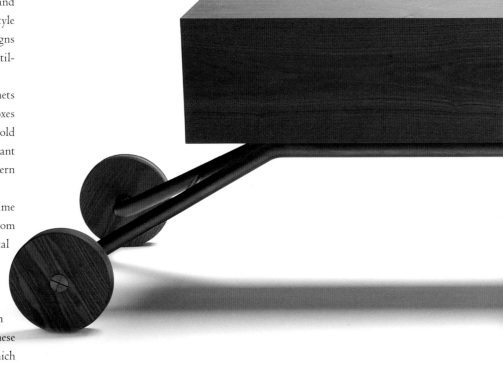

When Katsushi Nagumo was a child, thirty or forty years ago, Japanese lived mostly without chairs, sitting on the floor and gathering around small tables set with numerous dishes at mealtimes. Furniture was kept to a minimum, brought out when needed, and stored after use. Nowadays this traditional living style has all but disappeared, yet Nagumo's furniture designs keep the spirit of those times alive through their versatility and flexibility.

Instead of individual chairs and tables, and cabinets with fixed purposes and locations, Nagumo designs boxes and boards that can contribute to a variety of household lifestyles. His work emphasizes Japan's famed, elegant minimalism, which often turns the established Western concept of furniture on its head.

The Coro-Hako (literally, "rolling box") is a prime example of this unconstrained furniture. Viewed from the side, it appears to be little more than a horizontal wooden box on casters, and yet it brings a smile to the face of the viewer, perhaps calling to mind a whimsical cartoon bug, planning its next move.

In the old downtown areas of Tokyo, benches can often be found in the alleyways between houses. These benches serve as anything from seats to tables, on which *sake* bottles and cups are placed or *shogi* chessboards rest, even as beds for taking an afternoon nap. Add casters to one such bench and you have the Coro-Hako: more versatile than an ordinary piece of furniture—and certainly more fun.

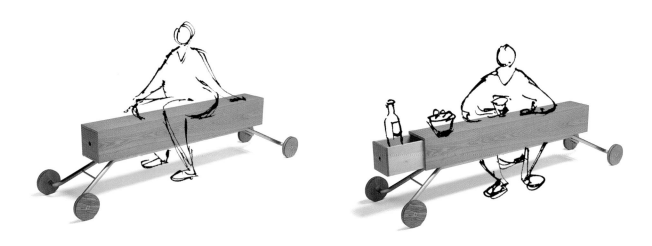

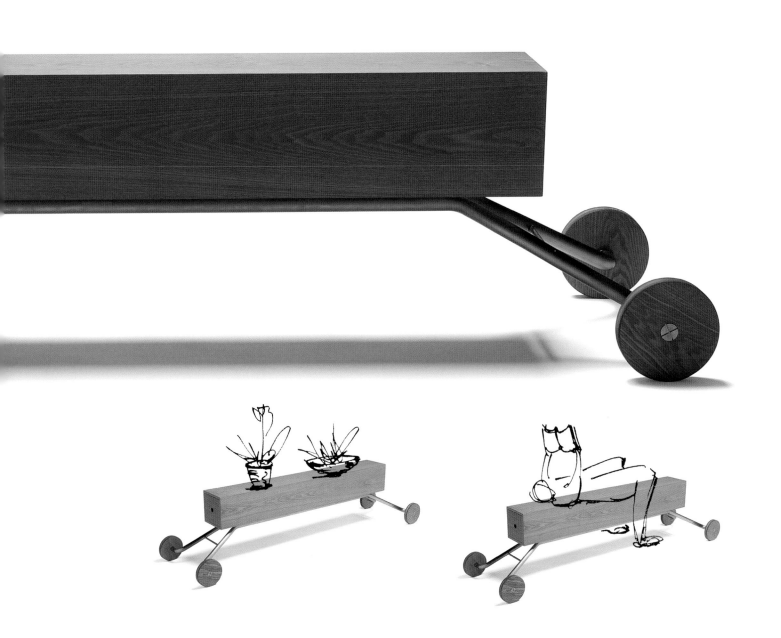

# Whopper Deluxe

**The Hamburger Stool**, 1994, Makoto Koizumi, steel/fabric, Φ13× 17inches (Φ33×42cm), Koizumi Douguten. Miniburger stool, 1999, Makoto Koizumi, steel/fabric, Φ11×12inches (Φ27×29cm), Koizumi Douguten

In 1996, Makoto Koizumi organized an exhibition of his work that included two of his most humorous designs, the Hamburger Stool and its older partner, the Rice Ball Stool. The former was named after the two circular cushions sandwiching its seating surface, while the latter took its title from Japan's favorite fast food, the triangular rice balls known as *omusubi*. The exhibition, entitled "Delicious Stools," was a resounding success.

But the origins of the Hamburger Stool go much further back than its namesake sandwich; in fact, they go back to an unglazed serving dish believed to have been used 1400 years ago, during Japan's Nara Period. The dish, known as a *gosu*, comprises two parts, a lid and a container, and although its original use is unknown, Koizumi was greatly enamored of its simplicity when he found it in an antique store one day. He bought the dish, took it home, and immediately began sketching.

"For some reason, I began to draw legs sprouting from the dish, so that it looked like a bug," he says. "It made me laugh, and I thought it would be fun to make a stool in a similar shape."

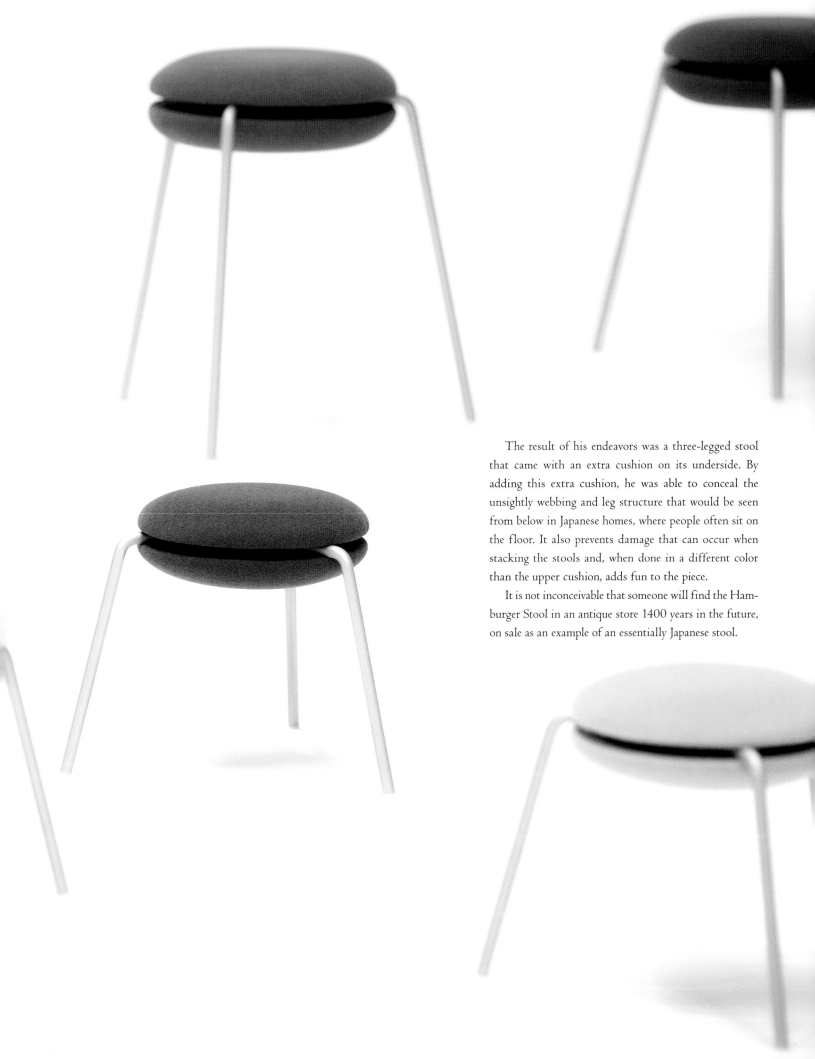

The result of his endeavors was a three-legged stool that came with an extra cushion on its underside. By adding this extra cushion, he was able to conceal the unsightly webbing and leg structure that would be seen from below in Japanese homes, where people often sit on the floor. It also prevents damage that can occur when stacking the stools and, when done in a different color than the upper cushion, adds fun to the piece.

It is not inconceivable that someone will find the Hamburger Stool in an antique store 1400 years in the future, on sale as an example of an essentially Japanese stool.

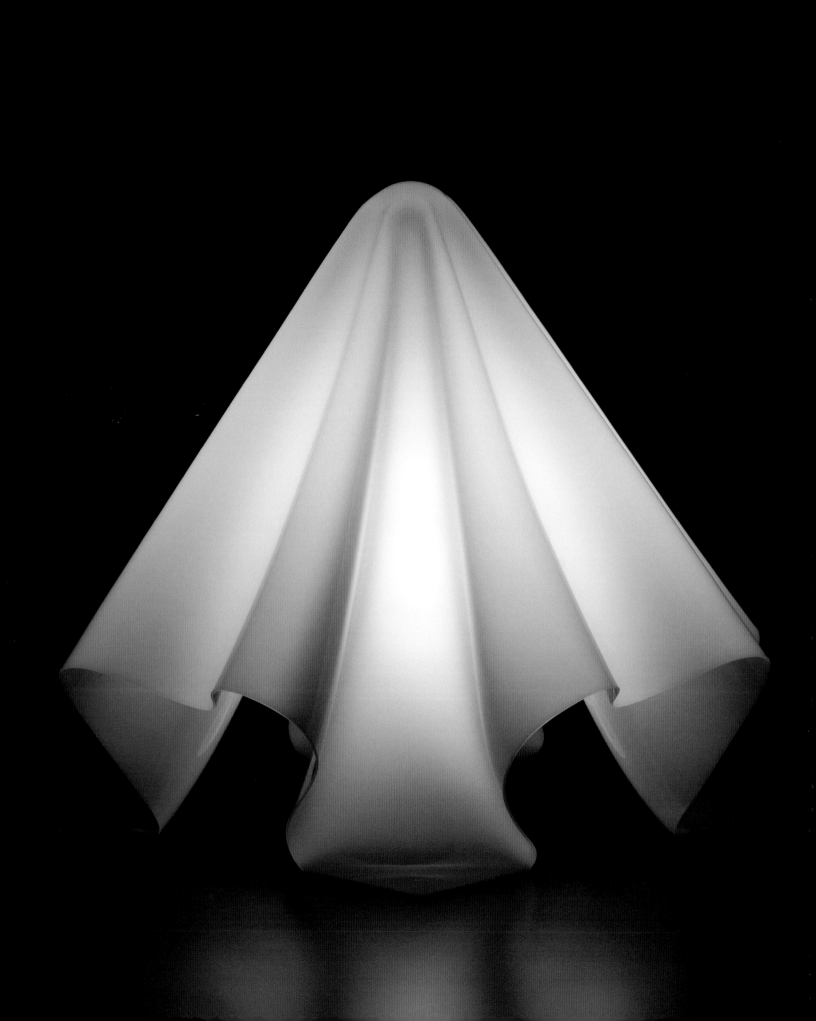

# Ghost Story

**Oba-Q(K Series)**, lamp, 1972, Shiro Kuramata, acrylic/milk-white color, 0.08inches (2mm) thick, [M type] W27.5×D27.5×H23inches (W70×D70×H58.5cm), Yamagiwa Corporation

This lamp, which resembles a piece of white cloth floating through the air, was created in 1972 by Shiro Kuramata, the renowned designer who died in 1991 at the young age of fifty-six. The K Series was initially intended only for exhibition, but it was commercialized after the attention it received and still sells today.

At its launch, the lamp earned the nickname "Oba Q," due to its similarity to the lead character in a popular Japanese animation series. *Obake no Q-Taro*, or "Q-Taro the Ghost," is a lovable phantom who has no body but drapes himself in a kind of sheet. He is capable of flying and making himself invisible. Kuramata often expressed an interest in the transient nature of things and in defying gravity, so—although he never said so—we might speculate that he felt an affinity for Q-Taro.

The K Series is created essentially by hand. An acrylic plate, about 0.1 inch thick, is heated in an oven to a predetermined degree of flexibility, draped over a support post, molded into shape, and then cooled. As a result, each piece ends up with unique folds.

The K Series is not intended to illuminate so much as to give shape to formless light, thus realizing the strong desire of its creator to subject light itself to a design process. The lamp's simple structure, comprising just one sheet of plastic, remains as fresh, humorous, and gravity-defying as it did over thirty years ago.

## New Horizons

**The Teiza-isu**, 1960, Junzo Sakakura Architecture Institute (designer; Daisaku Choh), oak/fabric, W21.6×D26.9×H25.6×SH11.4 inches (W55×D68.3×H65×SH29cm), Tendo Co., Ltd. RIGHT: Persimmon Chair (small chair [1960], redesigned in 2006), Daisaku Choh, molded plywood (beech), W18.9×D21.8×H33.1×SH17.7 inches (W48×D55.4× H84×SH45cm), Metropolitan Gallery Inc.

The chair has a relatively short history in Japan. Introduced during the Meiji Restoration of 1868, it slowly gained popularity among the upper classes while designers figured out ways of adapting this intrinsically Western piece of furniture to the Japanese lifestyle.

In 1960, the year in which Daisaku Choh designed his Teiza-isu, home life in Japan still centered around low tables on woven tatami straw mats. People sat on the floor in one of two characteristic styles: *seiza*—with legs tucked straight back under the body; or *agura*—legs crossed.

Choh hit upon the concept of the Teiza-isu during a conversation with a client whose house he was designing. The client requested "a chair I can relax in, at least when I'm watching TV, even if I mostly sit in seiza."

Choh realized that chair legs could easily damage fragile tatami, so he fashioned the leg portions from light plywood laminate in longitudinal plate form, thus spreading the load through increased contact between the legs and the mat.

Later that year, when the Teiza-isu was selected as an entry in the prestigious 12th La Triennale di Milano exhibition, Choh decided to further modify his design, giving the back and seating surfaces more of a curve and upholstering them to enhance comfort. He also simplified the leg section. He then put this second version into commercial production, and it remains substantially unchanged.

The Teiza-isu is a perfect example of a uniquely Japanese adaptation of a Western concept. It is simultaneously representative of its time, and timelessly elegant.

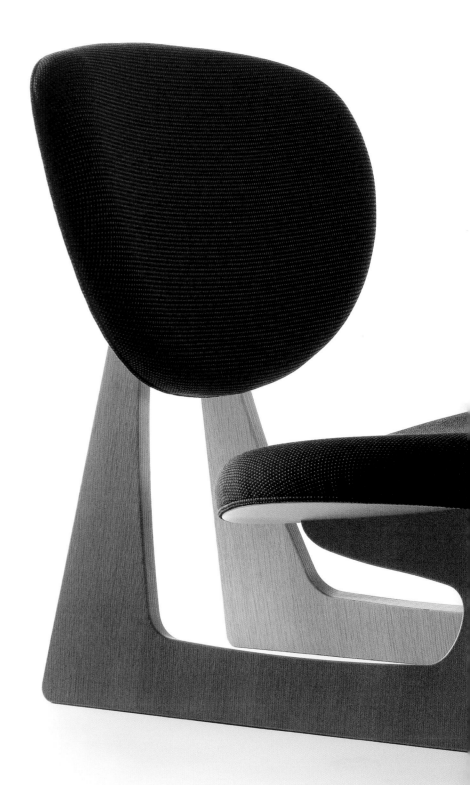

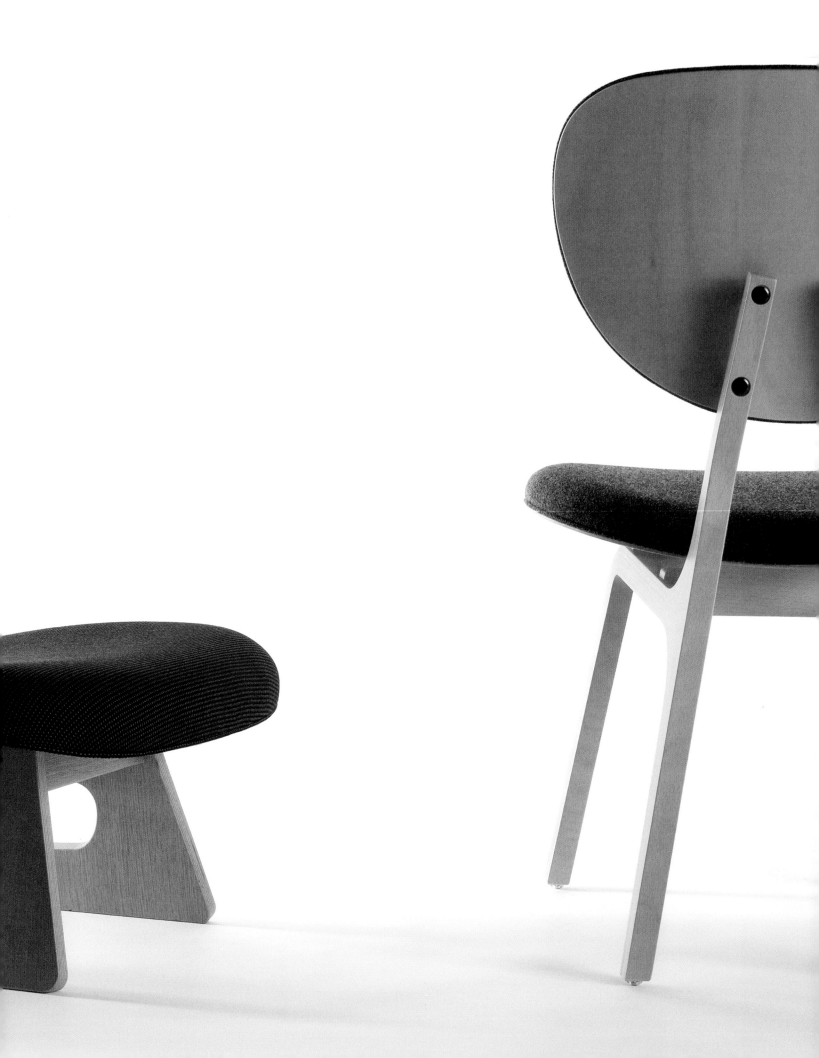

# A Light Fantastic

**Akari**, 1951 (Akari [1N] designed in 1969, W9.4×H16inches [W24× H41cm]), Isamu Noguchi, Japanese paper/steel, Ozeki & Co., Ltd.

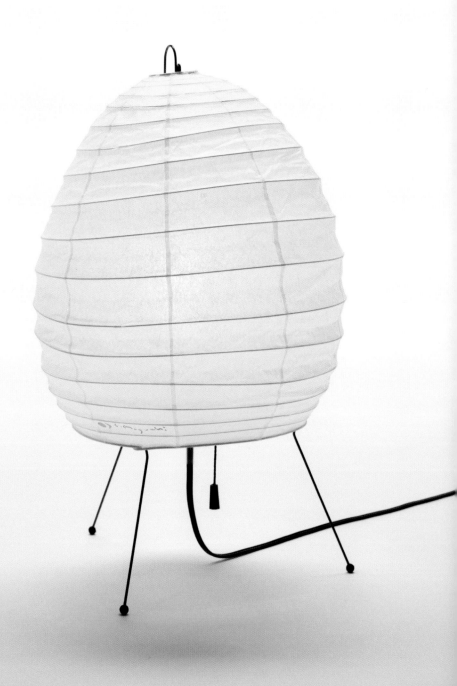

When sculptor Isamu Noguchi first visited Gifu in 1951, he spent an evening aboard a traditional pleasure boat decorated with the Japanese lanterns for which the area is famous. Shortly afterward, he tried his hand at designing a new version.

Noguchi had long held an interest in traditional Japanese lanterns made from *washi* paper and bamboo ribs, and to deepen his understanding of the materials and processes, he returned to Gifu several times. He made his own test pieces while observing the lantern craftsmen.

Around 1952, with the help of an expert craftsman, Noguchi produced around twenty "lighting sculptures," which formed the basis for the Akari. Although he employed traditional Gifu techniques, his finished lanterns were unique for their time: thick bamboo ribs formed the lamp frame, washi of the sort used for Japanese sliding screens was affixed to the frame, and a simple lighting mechanism was inserted. The lamp may be viewed as an *objet d'art*, issuing a gentle, soft glow, yet it is uncomplicated, comprising a small number of parts. It is also highly practical in that it can be folded, accordion-like, for portability.

The Akari did not meet with immediate success at home, but enjoyed excellent reviews overseas. It has undergone so many modifications and variations that today approximately two hundred types are available, while copycat versions often stand side-by-side on store shelves.

Noguchi was born in the USA in 1904 to a Japanese father and an American mother. He lived in Japan from the age of two to thirteen, then returned to America, where he began his career as a sculptor. This international upbringing allowed him to reacquaint himself with Japanese materials and handicrafts at a later age and to apply them in his creation of many unique modern designs.

## Everyday Icon

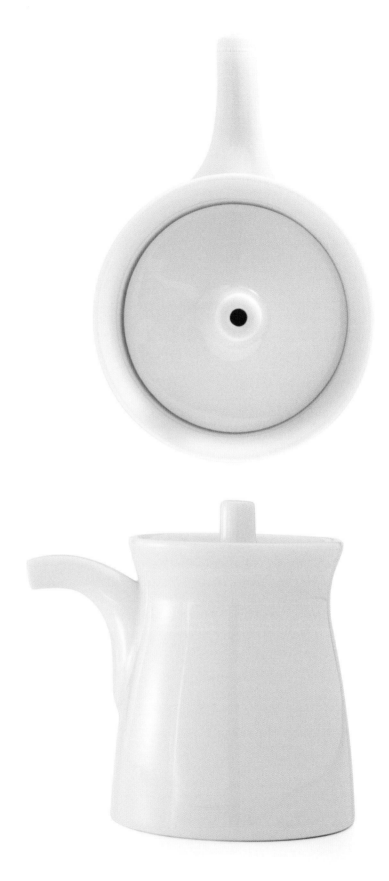

**The G-Type Soy Sauce Bottle**, 1958, Masahiro Mori, porcelain, [large type] W3.7×D2.7×H3.5inches (W9.5×D6.8×H9cm), [small type] W3.0×D2.2×H3.5inches (W7.7×D5.6×H7.2cm), Hakusan Porcelain, Ltd.

Soy sauce is essential to Japanese cuisine, not only as a seasoning for cooking, but as an individual component of almost every meal. It is almost impossible to imagine a Japanese dining table without a bottle of *shoyu* confidently displayed, for pouring into small saucers as a dip for *sashimi* or drizzled over cold tofu.

Since its debut almost a half-century ago, the G-Type Soy Sauce Bottle has become Japan's default soy-sauce server, often seen in private homes, on the counters of sushi bars, and in restaurants of all types and classes. Its enduring popularity is most likely due to its simple elegance, affordability, user-friendliness, and mass appeal.

Designer Masahiro Mori created the G-Type bottle in 1958, and, ever since, it has been in constant production at the Hakusan Porcelain Company in the famous pottery town of Hasami, Kyushu. To achieve its drip-proof quality, Mori subjected the bottle's upwardly curved pouring lip to numerous modifications during testing. Further research prompted him to add the hole in the lid, which can be blocked by the server's finger to control the rate of flow. The bottle's simple shape is perfectly suited to mass production, yet its innocent, artless lines accentuate the graceful motion required to pour the sauce, with the forefinger controlling the flow rate while the thumb and other fingers grip the body.

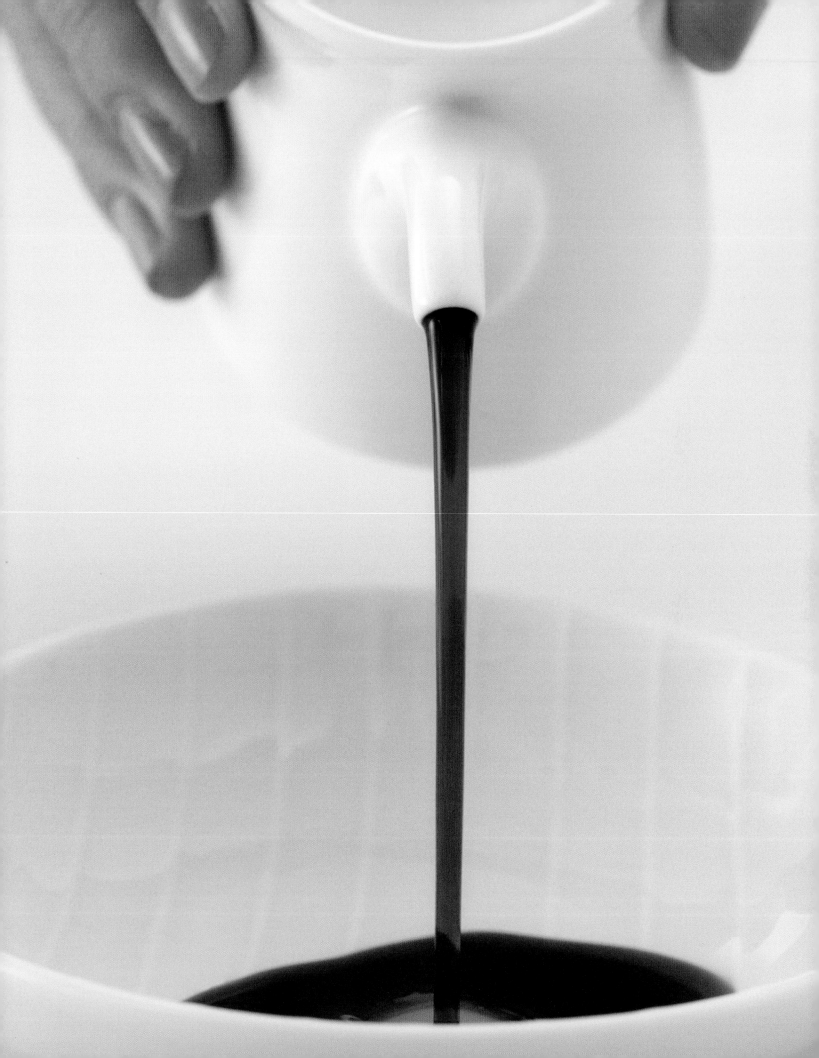

## Celebrating Rice

**The Shallow Rice Bowl**, 1992, Masahiro Mori, porcelain, φ5.9×
2.1inches (φ15×5.3cm), Hakusan Porcelain, Ltd.

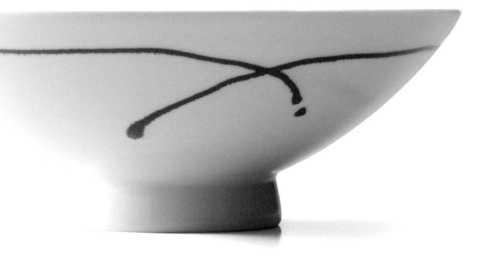

Western traditions, customs, and cuisines make constant inroads into Japan, but one thing that stubbornly refuses to change is the standard meal, which centers on a bowl of white rice. In the typical household, everyone has his or her own personal bowl, filled with white rice and held in one hand, while the other hand works a pair of chopsticks. The conventional rice bowl has specific dimensions: a diameter of four and three-quarter inches and a height of two and one-eighth inches, and is made to keep rice warm for as long as possible. But this is no longer necessary.

Throughout his career as a designer, Masahiro Mori has focused on the modernization of Japanese ceramics. Observing the country's rapid postwar development, he noticed changes also occurring in eating styles: tables became larger, the number of side dishes served with rice and miso soup increased, and microwave ovens for reheating and defrosting became ubiquitous. This gave Mori the freedom to design a vessel purely from aesthetic concerns—mainly, that is, to show the rice in the most attractive way.

In contrast to the conventional rice bowl, the Shallow Rice Bowl is wide and flat, with a diameter of six inches and a height of two inches. It is strikingly different from its forerunners, and despite its size is not difficult to lift or use. Mori has made it available in over 250 patterns, from the refined to the funky, and suitable for all ages.

By reinventing the rice bowl to reflect modern sensibilities, Mori has created a new relationship between the bowl and its contents—one that celebrates the beauty of the food inside. In a country where rice is often eaten three times a day, the significance of this achievement is not to be underestimated.

# Tea? Y Not?

**Tottotto,** Y-pot, 1996, Kazuhiko Tomita, H6.7 × W3.7 × L7.5inches (H17×W9.5×L19cm), ceramic body+*yusubai* white glaze/*ruri* blue glaze+rattan handle, 2.5-dimensional design

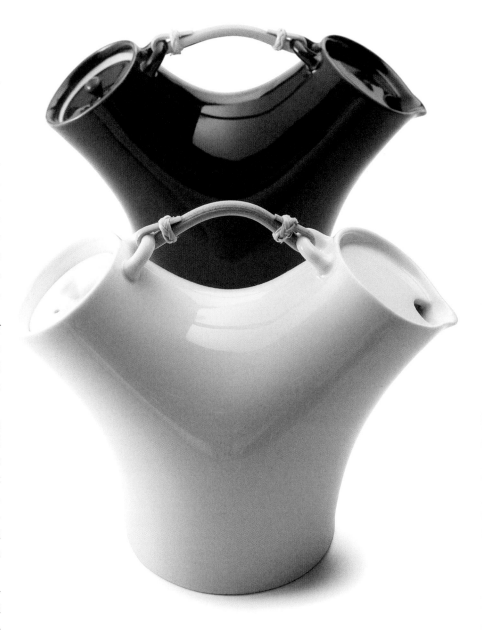

The letter "Y" inspired designer Kazuhiko Tomita when he created the Tottotto teapot. "Y symbolizes many natural phenomena," says Tomita, "such as cell division, the branches of trees, and the course of a river." In this playful vessel, the left and right forks of the Y form the teapot's lid and spout.

Tomita is the founder of the "2.5-dimensional design" company, and divides his time between Japan and Italy. He says the Tottotto symbolizes the balance between East and West. It also represents the opposition between two dimensions and three dimensions, and the traditional and modern. He was highly conscious of these aspects when designing the Tottotto, ensuring that the solid, European-style body flowed smoothly into the delicate detail of the Asian-style pouring lip. The vine handle also serves as a bridge between East and West, creating a sense of equilibrium between forces.

Tomita designed the Tottotto in his hometown of Nagasaki. In local dialect, "*tottotto*" means that a place or a seat has been reserved. The word also echoes the sound of tea being poured, and when written in Japanese is a palindrome, further reflecting the pot's symmetry.

The lid of the pot inclines away from the pouring direction, enhancing its stability so that it does not fall off, while the thick base lowers the center of gravity. The body is glazed in the colors of old Tokyo: a subtle light blue known as *yusubai* and a noble cobalt known as *ruri*. The unusual shape made it difficult to employ traditional production methods, and the designer approached many producers and worked with numerous craftsmen before achieving the finished pot.

Tomita is a supporter of the movement *Pensa Globalmente, Actua Localmente* (Think Globally, Act Locally), and the Tottotto, with its Nagasaki roots and intercontinental form, perfectly embodies this philosophy.

# Ringing in the Years

**ring ring**, tableware, 2000, Shin Nishibori, ceramic, various dimensions, Ricordi & Sfera Co., Ltd.

Japanese porcelain has a long history, but it was only after the end of World War II that commercial design began to play a serious role. The ring ring tableware series was launched in 2000 to mark the arrival of the new millennium. It uses overlapping rings as a motif, symbolizing the three zeros of that special year.

Ring ring was created when Shin Nishibori, a teacher of design, received a commission for a tableware range to be used principally in cafés and restaurants. By coincidence, he had set his students the task of creating designs based on the theme, "A present for the new millennium." Under normal circumstances, he would simply have chosen the topic and evaluated his students' efforts, but since this was a unique occasion, he decided to join in.

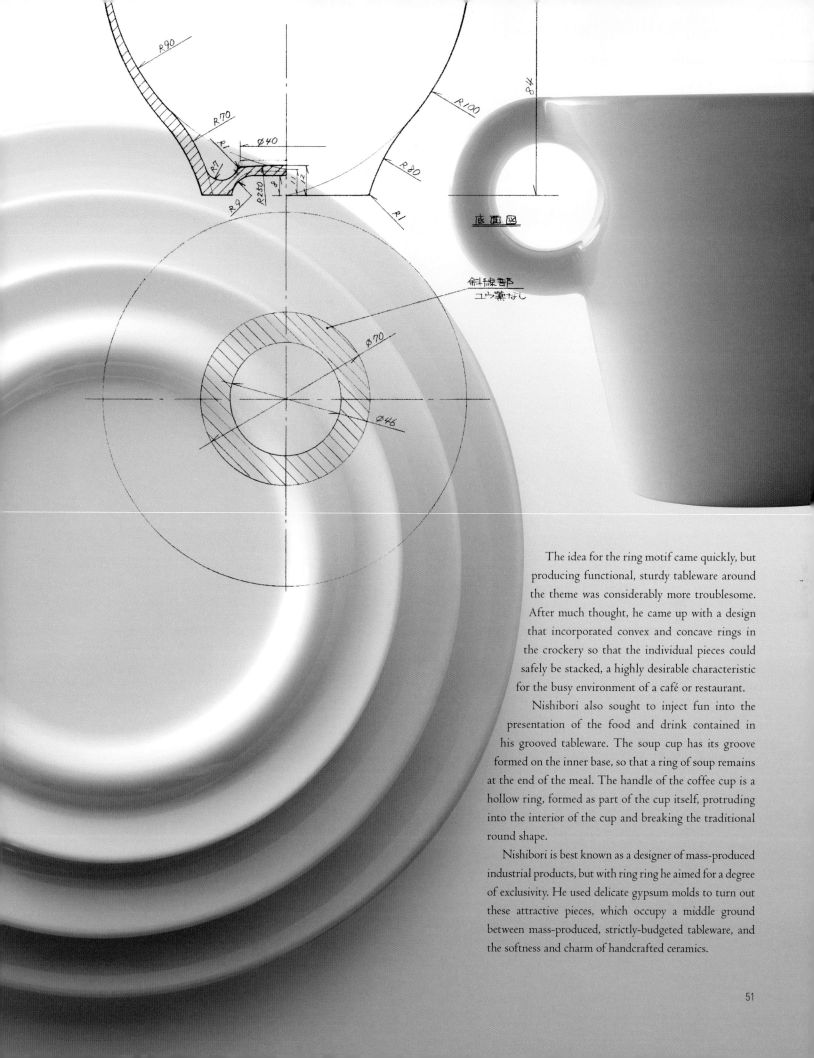

R90

R70

R1

Ø40

R7

R9    R250    8    11    12

R100

R80

R1

84

底面図

斜線部
ユウ薬なし

Ø70

Ø46

The idea for the ring motif came quickly, but producing functional, sturdy tableware around the theme was considerably more troublesome. After much thought, he came up with a design that incorporated convex and concave rings in the crockery so that the individual pieces could safely be stacked, a highly desirable characteristic for the busy environment of a café or restaurant.

Nishibori also sought to inject fun into the presentation of the food and drink contained in his grooved tableware. The soup cup has its groove formed on the inner base, so that a ring of soup remains at the end of the meal. The handle of the coffee cup is a hollow ring, formed as part of the cup itself, protruding into the interior of the cup and breaking the traditional round shape.

Nishibori is best known as a designer of mass-produced industrial products, but with ring ring he aimed for a degree of exclusivity. He used delicate gypsum molds to turn out these attractive pieces, which occupy a middle ground between mass-produced, strictly-budgeted tableware, and the softness and charm of handcrafted ceramics.

## The Taste of Bamboo

**Taketlery**, cutlery, 1999, Takashi Ashitomi, bamboo, various dimensions, SAAT Design Inc.

Takashi Ashitomi hit on the idea of producing bamboo cutlery after being struck by the unpleasant disparity—in both design and materials—between the wooden chopsticks used to eat Japanese food and the metal utensils employed for Western food. To narrow the gap, he created this harmonious set of eating tools, to enhance the enjoyment of any meal.

Assisting Ashitomi was Haruo Kai, an eighty-three-year-old bamboo craftsman. Ashitomi was initially drawn to a pair of Kai's chopsticks: they were flat, and matched the contours of the hand perfectly. Based on this form, Ashitomi sketched Kai a knife, fork, and spoon, each with a chopstick-shaped stem. The resulting design was a perfect blend of beauty and unity.

The cutlery is made from thick *moso* bamboo with a diameter of ten inches. Both natural and carbonized bamboo are used, the latter being natural bamboo that has been steamed to enhance its strength and produce a unique luster. It was never Ashitomi's aim to produce expensive works of art, and on this point Kai agreed. He designed a set of tools that enabled him to create each piece by hand (with the characteristic joint on its stem), while keeping costs down.

Sadly, Kai has since retired and production has halted. But requests for new bamboo cutlery show no sign of abating, such is the simple brilliance of Ashitomi's design. This is a fusion of Eastern and Western styles perfectly suited to Japan, where global gastronomic cultures exist happily side by side.

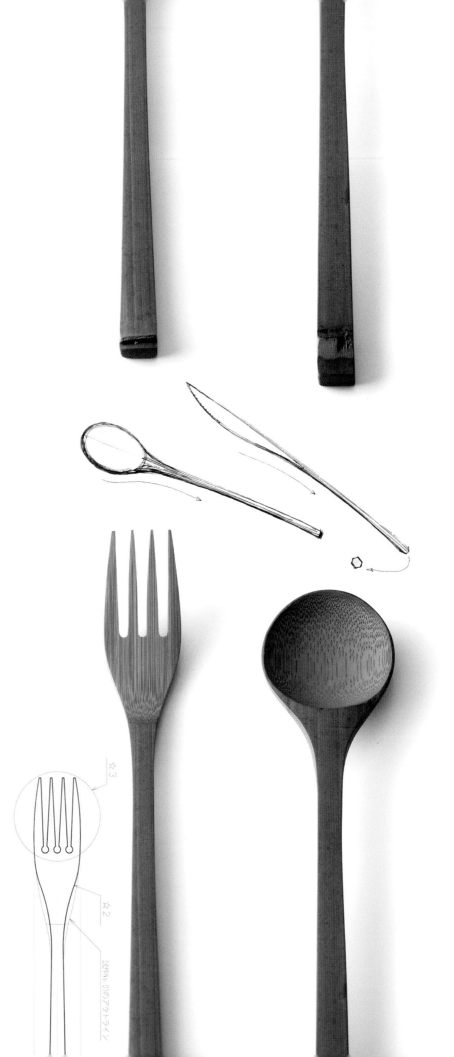

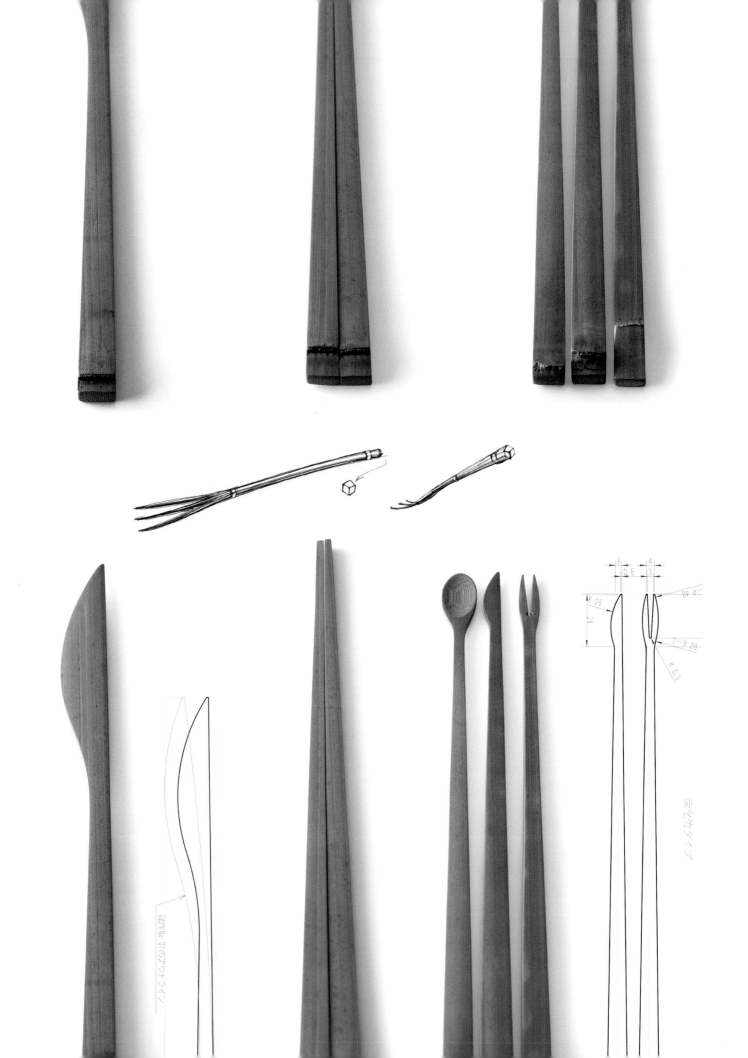

## Steam Dreaming

**ZUTTO**, rice cooker, 2004, Fumie Shibata, plastics/stainless steel etc., W9.8×H7.1×D13.0inches (W25×H18×D33cm), Zojirushi Corporation

Rice is the staple of the Japanese diet, so it is not surprising that this electric rice cooker was created by Fumie Shibata, a designer renowned for her durable and attractive everyday objects.

In tackling her manufacturer's brief—to create an appliance that will blend seamlessly into a regular Japanese kitchen—Shibata pictured her rice cooker in an old-fashioned kitchen, filled with aluminum pots, skillets, and kettles. Her finished design looks back to the past without sacrificing modern convenience, and, with its inherent durability and timeless elegance, casts an eye to the future.

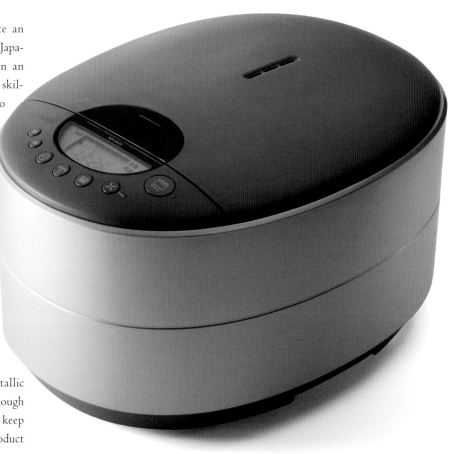

In addition to the old-style kitchen, Shibata looked for inspiration to the traditional Japanese craft of *magewappa*, in which thin slices of wood are boiled and then bent into circular or elliptical bowls and boxes. The Japanese love magewappa products for their beauty and simplicity, and they are still commonly found in use as lunch boxes and rice tubs.

By forming the rice cooker in a magewappa shape, Shibata found she had plenty of extra space for the necessary mechanisms such as electrical circuits. She gave the exterior of the rice cooker a metallic finish, reminiscent of a sturdy pot or kettle, and although metallic paint, rather than real metal, was used to keep costs down, the sleek contours give the finished product a pleasingly expensive look.

Shibata's rice cooker is from a series of household electrical goods intended to be used daily over a long period of time. The series is titled Zutto, which translates roughly as "forever."

## Rise and Shine

**Contrast/Aroma**, espresso maker, 2004, Ichiro Iwasaki, aluminum/polyamide, Φ3.2×4.7×H8.3inches (Φ8.2×12×H21cm), Ricordi & Sfera Co., Ltd.

When Ichiro Iwasaki lived in Italy, he noticed how seriously the locals took their coffee, using espresso to punctuate their day. Inspired by this important activity, and the design challenge of how to enhance it, Iwasaki set about building an espresso maker that would fit seamlessly into its user's daily routine. He purposely ignored traditional and recently designed models, hoping instead to create a simple utensil that would deliver a sense of quiet satisfaction. His efforts culminated in the Aroma.

Iwasaki says his initial inspiration came from the cool, crisp air and gentle sunlight of an Italian morning. He wanted the Aroma to blend with a sleepy-morning kitchen scene, and one image that stuck with him was that of a milk bottle, with its smooth, clean contours. Similar to the milk bottle, the Aroma is sturdy and informal, yet of high quality. It went on sale in the 2005 Milan Salone and has garnered the praise of buyers in Europe and around the world.

The Aroma forms one part of the Contrast project, which was begun in Kyoto in 2000 by Shigeo Mashiro, representing restaurant and store owners Ricordi & Sfera. Contrast consists of a series of everyday utensils, centering on tableware, developed by Japanese designers, manufactured in Europe, and sold initially to European markets. Iwasaki has been involved in all aspects of Contrast designs, and his intention is not to raise shrieks of surprise, but calm appreciation. He realizes the difficulty of intruding upon the long tradition of European-made tableware, but he believes that if his designs are good, they will speak for themselves.

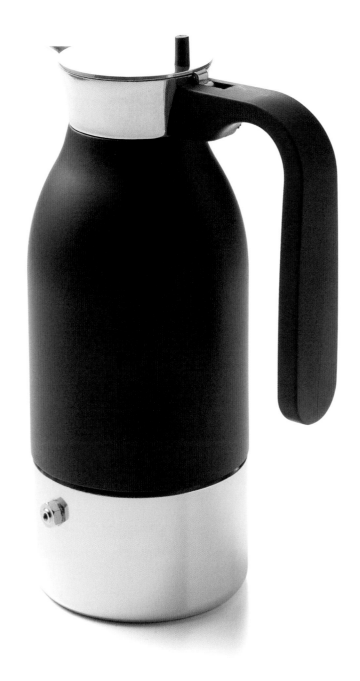

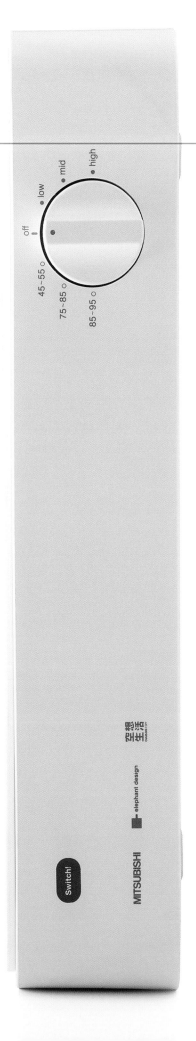

## Design on Demand

**The Compact IH**, desktop cooking range, 2005, design: Klein Dytham Architecture, product development: Kohei Nishiyama, PET resin & PBT resin, W12×D12×H2.4inches (W30×D30.2×H5.6cm), Mitsubishi Electric Home Appliance Company

The Fantasy Life website run by Elephant Design is a "virtual space," established to turn consumers' ideas into products. It works like this: when an interesting suggestion for a new product is received, the site operators initiate the process of design and product development. If the project attracts enough attention to secure a profit margin, an order is placed with a contracted manufacturer. Elephant Design created this DTO (Design to Order) business model in 1999, transforming the conventional one-to-one, order-made system into a one-to-many, mass-production model.

The Compact IH is one product that came to life thanks to Fantasy Life, after extensive research into the eating habits of ordinary households. The research found that many families enjoyed cooking at the table rather than in the kitchen but could not find the right tools to do so. The researchers also received requests for an appliance that "is easy to clean," "can be used for breakfast, lunch, and dinner," "blends nicely with white crockery," and "doesn't take up much space."

The design firm Klein Dytham Architecture was hired to realize a design, and then a manufacturer was approached to discuss commercial viability. At the same time, photographs of a test piece were posted on the Fantasy Life website and advance orders were taken. More than 2300 applications secured the future of the Compact IH.

The finished product can be stored upright to save space, and its cord can be stowed in the rear. It has a high-sensitivity heat regulation mechanism that makes it

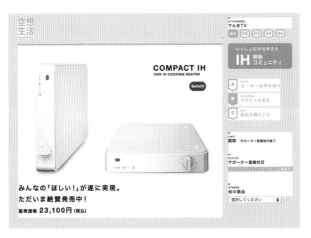

suitable for Japanese, Chinese, and Western cuisines. Its shiny white finish is clean, simple, and chic. Thus the design of the Compact IH reflects all the requests made by the public through the DTO system.

Kohei Nishiyama of Elephant Design has grand dreams for the future of Design to Order. "DTO is an invention in itself," he says. "As the concept catches on, there's no reason why it shouldn't transform the entire industrial establishment."

Nishiyama's DTO system is a response to his realization that many people couldn't find the products they wanted, in spite of a worldwide market overflowing with *things*. He felt that people were particularly dissatisfied with the quality of domestic appliances and other mass-produced items. He decided to turn the concept of supply and demand on its head by focusing on the wants of a specific person rather than an unspecified, unknown mass.

His assumption that a model based on one person's desires would be attractive to others proved to be correct. Of course, DTO would not have been possible without the Internet, as the progress of this cooking range shows (left). Through this medium, Nishiyama hopes that DTO will continue to provide like-minded people with products they truly want.

# The Caked Crusader

**Boya**, storage stand for cooking tools, 2006, Hiroshi Kajimoto, acry-lonitrile-butadiene-styrene resin, W7.5×D7.5×H18.1inches (W19.2×D19.2×H46cm), Kai Corporation

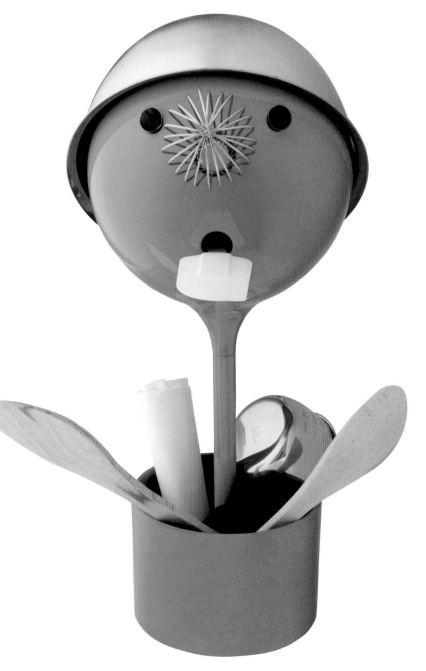

This quirky green fellow makes an impact in the kitchen. His name is Boya, and he is designer Hiroshi Kajimoto's storage system for all the bits and pieces needed for cake making—the whisk, spatula, molds, measuring cup, and so on. Boya also expresses Kajimoto's desire to inject more fun into this traditional, parent-child activity.

The tool that gave Kajimoto the most trouble was the large stainless steel mixing bowl. Once the designer had settled on the bowl as a hat, however, Boya came to life. The whisk forms the nose, the eyes are cream tubes, and the spatula protrudes like an outstretched tongue.

The green of Boya's body hints at the camouflage of a soldier, and herein lies Kajimoto's hidden theme: his wish for peace, and—outlandishly, perhaps—his wish for a world in which soldiers brandish whisks instead of guns. This is not something Kajimoto shouts about, but it is nevertheless an idea close to his heart.

"Here we are in the twenty-first century, yet there seems to be no end to war and conflict," says Kajimoto. "Design should be something that brings happiness to all people rather than just the lucky few. I hope Boya will serve as a soldier who brings smiles to children's faces."

# A Mother's Warm Touch

**Ken-on-kun**, clinical thermometer, 2004, Fumie Shibata, plastics/
stainless steel, etc., W1.4×H4.9×D0.6inches(W3.4×H12.5×D1.5cm),
Omron Corporation

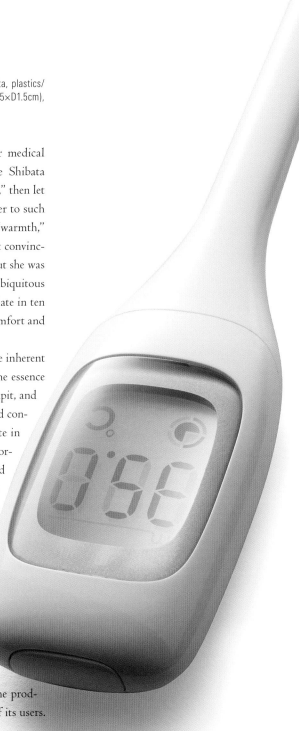

In creating this home-use thermometer for medical
equipment maker Omron, designer Fumie Shibata
brainstormed around a mental image of "home," then let
her instinctive associations for the word lead her to such
concepts as "mother," "trust," "cleanliness," "warmth,"
"wisdom," and "reliability." It took some effort convinc-
ing the company to go along with her vision, but she was
confident she had significantly recast this ubiquitous
and important instrument—Omron's first update in ten
years—into a product that offered motherly comfort and
reassurance to the user.

Shibata says the best designs spring from the inherent
qualities of the object being designed. Thus, the essence
of a thermometer is its "insertion" into the armpit, and
the visual "delivery" of the result. Yet she found con-
ventional digital thermometers to be inadequate in
both of these areas. The temperature-sensing por-
tion of the tip, for example, remained unchanged
from the mercury ancestor, with a diameter
too narrow to hold comfortably in place. To
compensate, Shibata set about making the
tip wider and flatter. This was techni-
cally difficult and expensive, but she was
able to convince the manufacturer of its
necessity. Next, she modified the digital
display, making the numerals large and
easy to read from both left and right.

The Ken-on-kun can be used with
ease even by small children, fulfilling a
major requirement of effective design—that the prod-
uct blends effortlessly into the everyday lives of its users.

## Sweet Talk

**Sweets**, mobile phone, 2006, Fumie Shibata, plastics etc., W1.9×
H3.7×D0.9inches (W4.9×H9.4×D2.4cm), KDDI Corporation

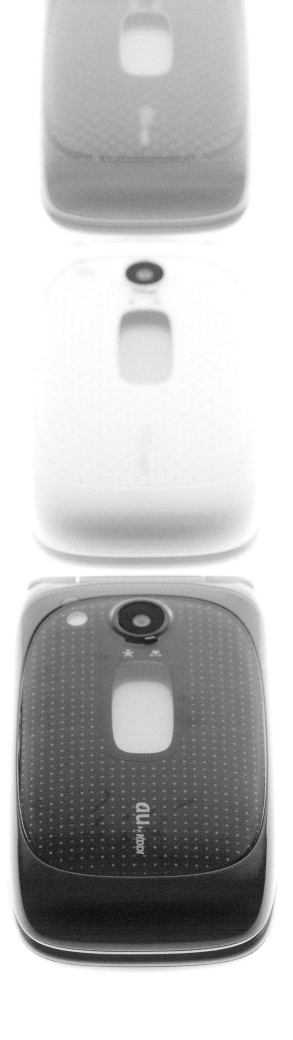

Sweets is the cell phone that resembles a blob of deli-cious-looking gelatin desert. It was designed by Fumie Shibata for a specific market: young teenage girls.

Says Shibata: "When I first received the commission, I realized that I no longer had an idea what young girls are like. After meeting with some of them, I learned they all shared a love of candy. That's where the Sweets con-cept came from."

Japanese cell phones began as business accessories and were almost always produced in silver and black—colors far removed from the tastes of young girls. Shibata heard complaints from the girls that their phones were uncool, or gave the impression they were borrowed from Dad. At her drawing board, Shibata pictured the girls using her phone. Somehow, the image of gelatin desert-covered candy and fruit, which the girls said they loved so much, stuck with her.

"I wanted to express the girls' freshness," she says. "Their playfulness, and their supple, young skin. That's how I came up with the idea of jellied candy—with its bright colors, its transparency, and its elastic texture."

Shibata has always believed that design is not simply a process of modifying the shape of an object, but of reforming the very essence of that object. Her perceptive and straightforward attitude toward the girls helped her develop this charming and striking device.

**IXY DIGITAL, Power Shot S100 DIGITAL ELPH, DIGITAL IXUS**, 2000, stainless steel, W3.4×H2.2×D1.1inches (W8.7×H5.7×D2.69cm), Canon Inc. BACK: IXY (ELPH, IXUS), 1996, stainless steel, W3.5×H2.4×D1.1inches (W9.0×H6.0×D2.7cm), Canon Inc.

PAGE 67: IXY DIGITAL 70 (Power Shot SD600 DIGITAL ELPH, DIGITAL IXUS 60), 2006, stainless steel, W3.439×H2.11×D0.85inches (W8.6×H5.35×D2.17cm), Canon Inc.

The Canon IXY debuted in 1996 and was an instant success. At a time when camera design favored functionality over aesthetics, the compact and stylish device took cameras in a new direction—away from the complex and cumbersome toward lighthearted products that doubled as fashion accessories.

Created to support a new type of film known as APS (Advanced Photo System), the IXY was shown in advertisements swinging from the neck of a model.

The IXY is distinct for its simple yet striking "box and circle" structure. A large circle centered on the lens is inserted within a square box. The logos are engraved vertically so that they can be read horizontally when the camera is worn, and the body is coated with specially processed stainless steel. In combination, these details announce that the camera is very much of a new generation.

Not surprisingly, when photography began its shift toward digital, the IXY's hugely popular concept and design were carried over without modification.

The IXY Digital went on sale in 2000, combining the stylish compactness of the original IXY with cutting-edge technology. It was the first digital camera to be embraced—or to put it more precisely—*worn*, by the general public.

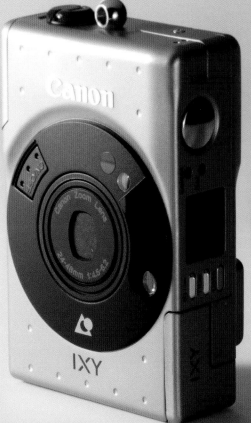
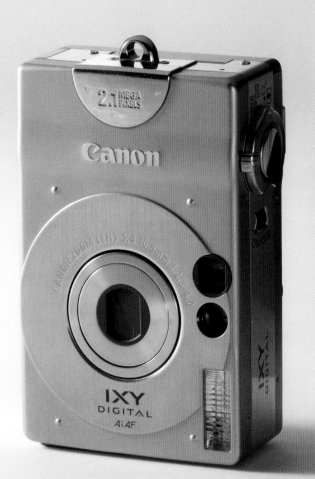

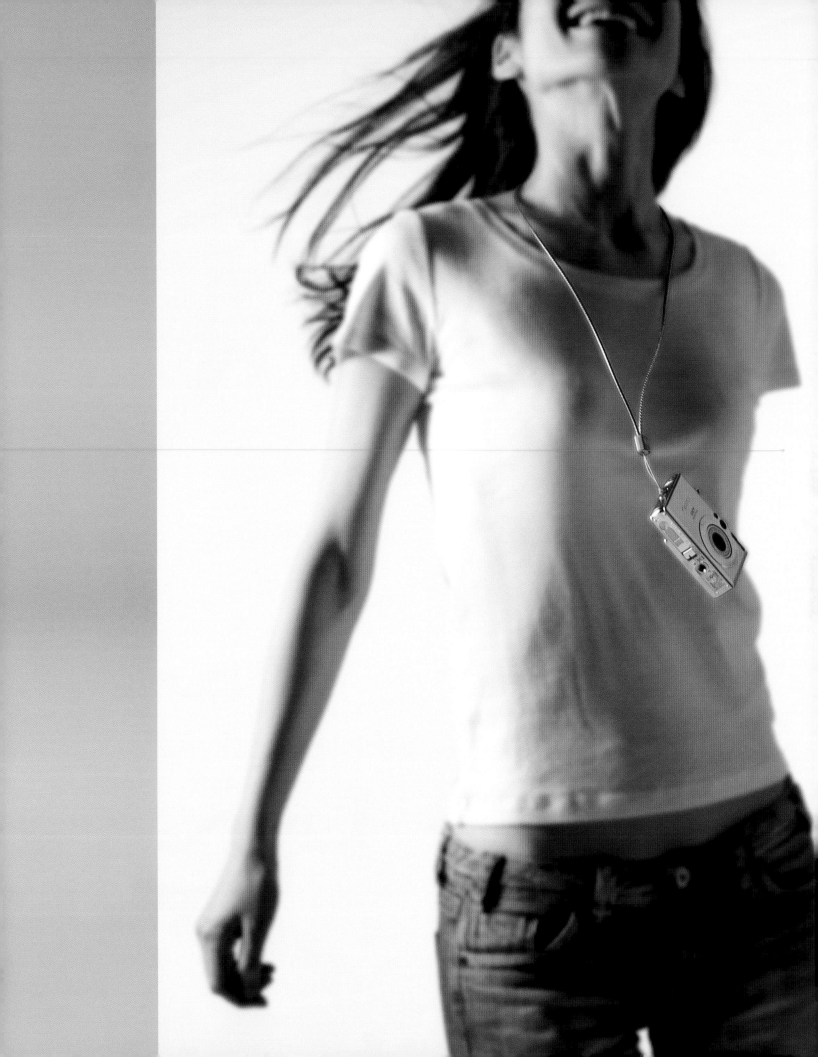

## Soundtracks for Life

**The Walkman® TPS-L2**, 1979, W3.4×H5.2×D1.1inches (W8.8× H13.35×D2.9cm), weight 13.7ounces (390g), Sony Corporation

PAGE 69 (FROM TOP): NW-E005, 2006, W0.9×H3.1×D0.5inches (W2.48× H7.9×D1.36cm), weight 0.9ounces (25g), MZ-E10, 2002, W3.2× H2.8×D0.4inches (W8.19×H7.22×D0.99cm), weight 1.9ounces (55g), WM-2, 1981, W1.2×H4.3×D3.1inches (W2.95×H10.9×D8.0cm), weight 9.8ounces (280g)

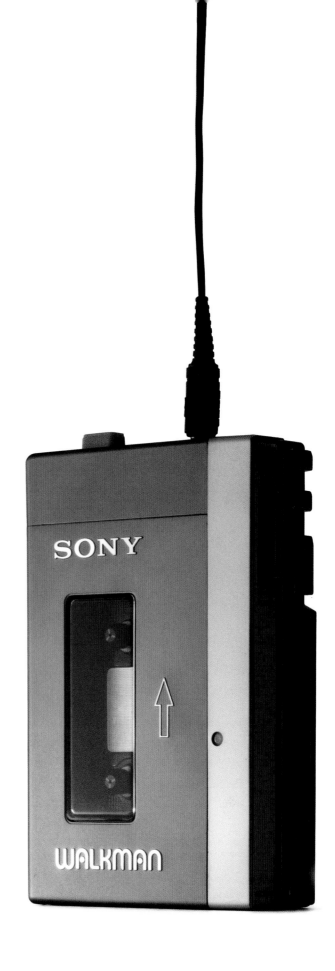

The year 1979 saw a seismic upheaval in consumer electronics, when the original Sony Walkman stormed the world. So revolutionary was the Walkman that it triggered a global lifestyle change.

The Walkman was invented in 1979, when Masaru Ibuka, then vice president of Sony, directed his development staff to adapt a stereo circuit to fit a small tape recorder. The tape recorder's speakers were removed and replaced with stereo earphones, and although the finished device was only capable of reproducing music, the sound quality was astonishing.

However, inside the company, the device met resistance, with sales staff voicing reservations about a machine that was unable to record. The Sony chairman overrode them, saying, "Kids can't live without music. If this machine lets them listen anywhere and anytime, it will be a success." As a consequence, the Walkman was moved into production and reached the market in record time.

Refinements continued, with designers and engineers collaborating to reduce the Walkman's size and weight. In 1981, for example, the second-generation model weighed in at a mere 280 grams (10 ounces), consolidating Japan's reputation for creating compact, lightweight, and quality products.

From today's perspective, the Walkman represents more than a revolution in design; it is single-handedly responsible for the inseparable relationship between music and everyday life that we now take for granted.

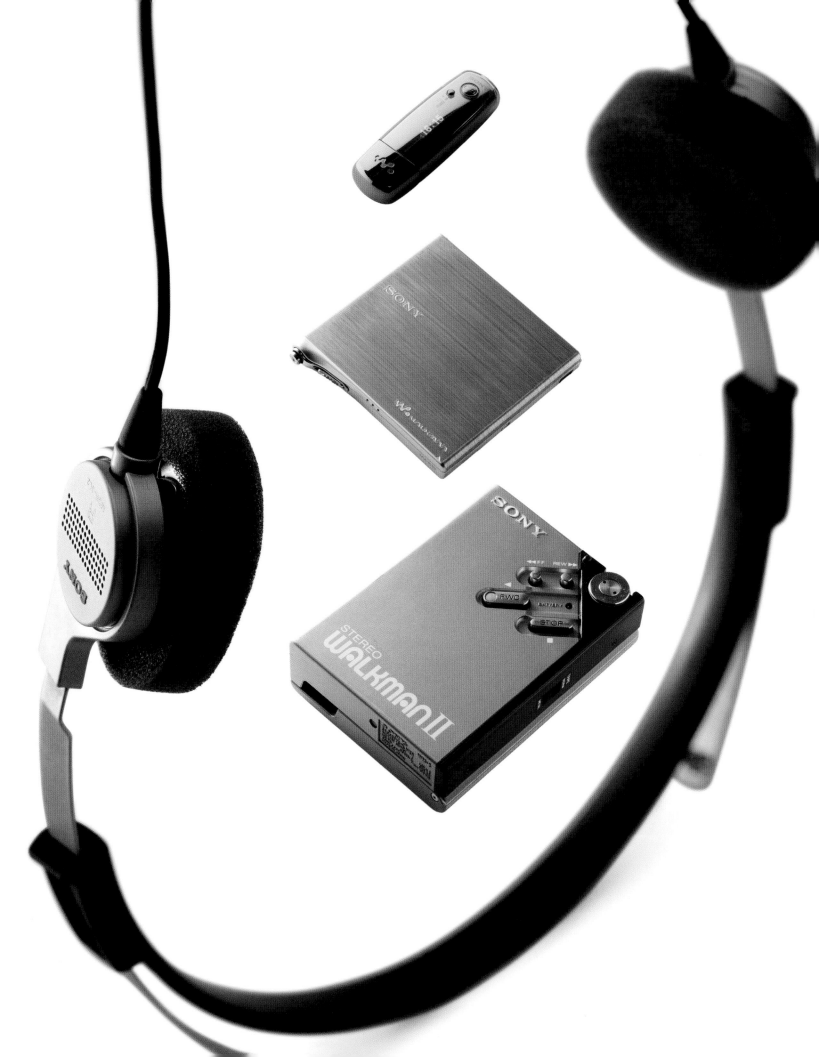

## Ringing True

**MUTECH/telephone 610**, 2000, Ichiro Iwasaki, ABS/acryl/alumi-num, 6.5×7.1×3.5inches (16.5×18×9cm), MUTECH

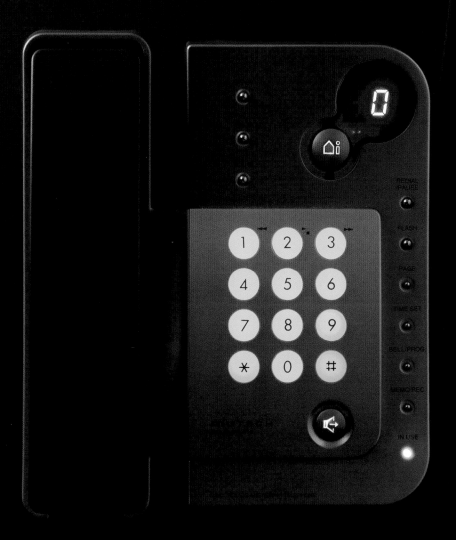

The downside of mass production—aesthetically speaking—is that most products are made for the largest possible market. Take the telephone, for example. The major Japanese phone makers have always empha-sized user-friendliness over elegance. And with countless new functions to be accommodated in the relatively small device, beautiful design has become even more marginal-ized. The telephone 610 reverses this trend, delivering functional simplicity, accessibility, and clarity.

Designer Ichiro Iwasaki says he wanted to strike a balance between simplicity and detail. He arranged the control buttons of his phone in sequence, according to their function, and in a vivid color that stands out from the smooth body, resulting in an expressive yet orthodox operating panel. The receiver fits perfectly with the main body, and all of the phone's constituent elements are appro-priately sized, creating a subdued yet assertive presence.

Iwasaki was commissioned to design telephone 610 in 1999 by the electronics division of the Korean Taekwang Industrial Company. The chairman of Taekwang, who is of the same generation as Iwasaki, was keen on refreshing the company's existing brands, without focusing exclu-sively on technical features. He had often commissioned renowned designers outside the company to reinvigorate its products.

At first, Iwasaki was hesitant to work with an unfa-miliar company. But during prolonged negotiations, he began to appreciate the chairman's ideas and enthu-siasm. After accepting the project and considering the company's ideas, Iwasaki suggested a completely new range, rather than simply a redesign project. Thus the MUTECH brand was established, with Iwasaki taken on as a designer.

With the telephone 610, Iwasaki has created a simple, beautiful device that balances form, color, and materials, and reflects its designer's honesty and sensitivity.

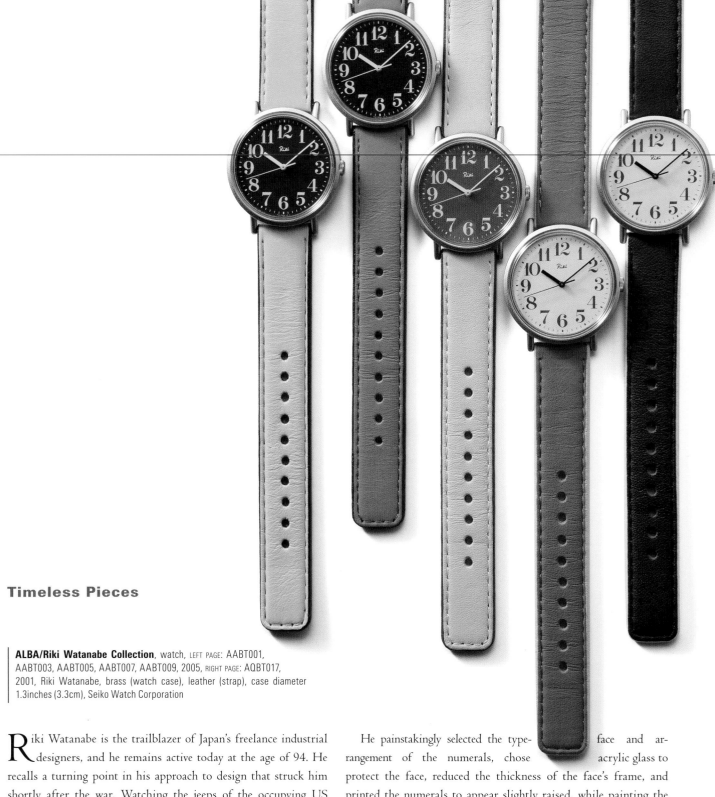

## Timeless Pieces

**ALBA/Riki Watanabe Collection**, watch, LEFT PAGE: AABT001,
AABT003, AABT005, AABT007, AABT009, 2005, RIGHT PAGE: AQBT017,
2001, Riki Watanabe, brass (watch case), leather (strap), case diameter
1.3inches (3.3cm), Seiko Watch Corporation

Riki Watanabe is the trailblazer of Japan's freelance industrial designers, and he remains active today at the age of 94. He recalls a turning point in his approach to design that struck him shortly after the war. Watching the jeeps of the occupying US forces, he was struck by the simplicity of their structure. "I realized then that I was observing an archetypal design," he says.

This belief in simplicity is evident in Watanabe's wristwatch, which debuted in 2001 as part of Seiko's ALBA range of reasonably priced watches. Watches of this price range tend to have a brief shelf life, soon usurped by the next trend, but with its clear, large numerals and appeal to both men and women, Watanabe's watch has become a perennial seller.

He painstakingly selected the type-face and arrangement of the numerals, chose acrylic glass to protect the face, reduced the thickness of the face's frame, and printed the numerals to appear slightly raised, while painting the face white to better contrast with the black numerals.

He revised his design repeatedly, refusing to compromise until he had realized his vision, and while he modestly suggests this was due to his clumsiness, in truth it is the sign of a master craftsman.

The watches shown here were launched five years after Watanabe's first version, with slight modifications. The black-and-white face is now joined by five two-tone versions, in traditional Japanese colors.

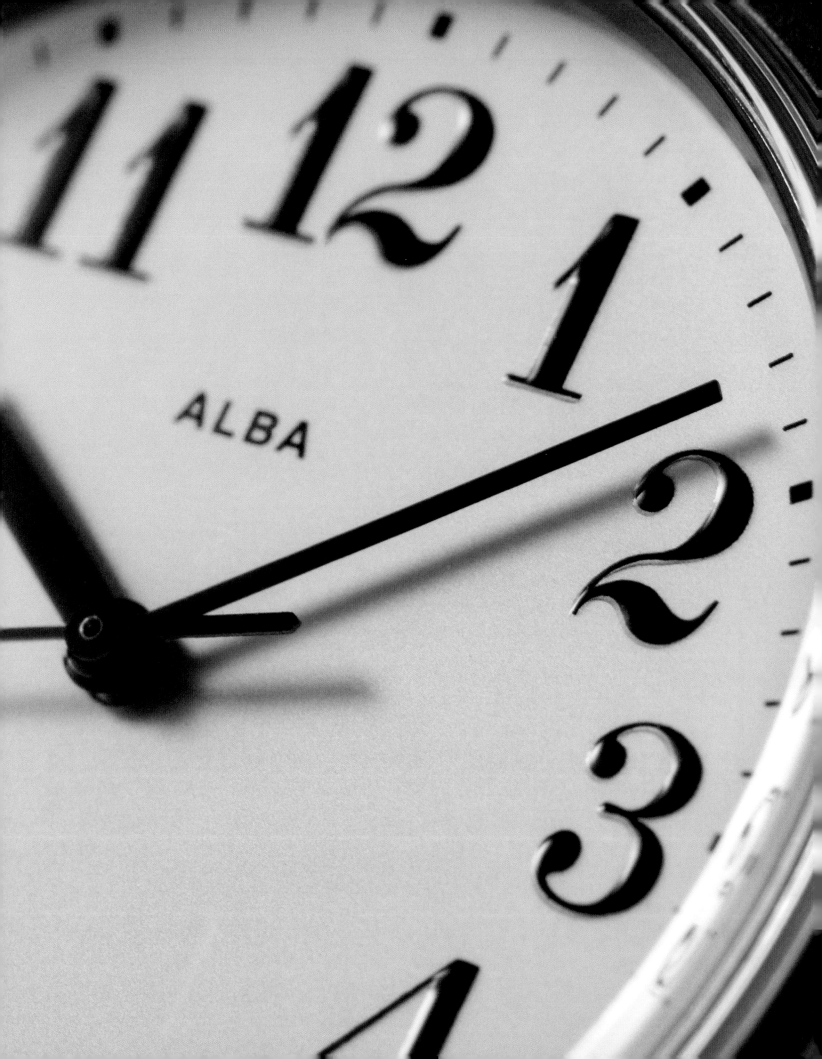

## The Block Clock

**to:ca**, clock, 2002, Koji Iwasaki, medium density fiberboard/maple sliced veneer, W8.3×H3.5×D3.5inches (W21×H9×D9cm), Takumi Kohgei

Like so many clever ideas, this unusual clock, on which electronic numerals appear to float on a block of wood, was born of coincidence.

Designer Koji Iwasaki had wanted to make a simple, fun clock to place on his desk and so visited Akihabara, Tokyo's electronics heartland, to buy a seven-segment LED kit. He initially intended to leave the clock circuitry exposed, but happened to have on hand a slice of timber veneer, with which he creates furniture models. For no particular reason, he held the red digits against the wood and, to his surprise, saw them shine through strikingly. He built the clock using a 0.019-inch-thick strip of maple for the face, with a sheet of thin Japanese paper affixed to the back of the face to increase strength.

The name to:ca comes from the Japanese word *touka*, meaning permeation, playing on the way the digits permeate the wood. The to:ca was first commercialized by Takumi Kohgei, an Asahikawa company specializing in fine wooden furniture, and distributed by the electrical appliance firm IDEA International.

With its synthesis of natural wood and electronics melding two of Japan's most famous traditions, the to:ca won the Bronze Leaf Prize at the Asahikawa International Furniture Competition of 2002.

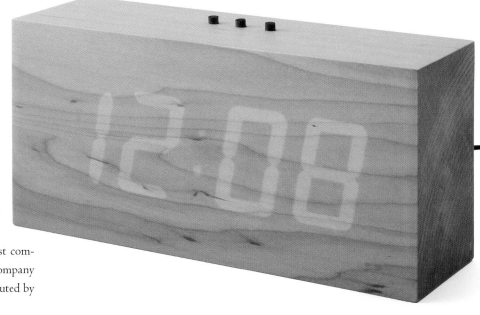

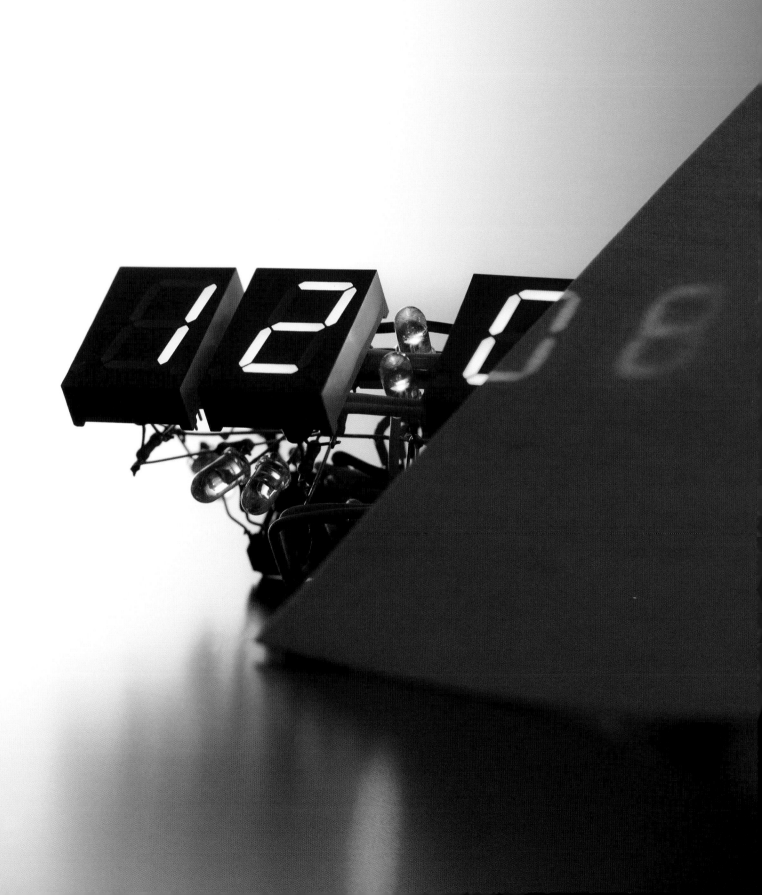

## The Mists of Time

**kehai**, clock, 2004, Makoto Koizumi, aluminum/polycarbonate, Φ5.1×D2.2inches (Φ13×D5.5cm), Takata Lemnos Inc.

In the town of Mino, home to Japan's paper industry for over 1300 years, designer Makoto Koizumi discovered some handmade paper for sliding screen doors that overwhelmed him with its translucence and beauty. The best sliding-screen paper lets in light while excluding wind and cold, and the superior Mino paper, made by master craftsmen, satisfies these requirements magnificently due to its pure whiteness, gossamer thinness, and resilience.

Following his visit, Koizumi pondered ways of incorporating this beautiful paper into everyday items. His initial product was a small paper box, housing a clock. A long hand, a short hand and a colored circle representing a second hand were subtly visible through the diaphanous paper covering the face, while sides made of slightly thicker paper concealed the clock mechanism. The hazy outlines of the hands imparted the sense of a clock trapped inside a box.

Several years later, Koizumi developed his paper clock into the product called Kehai—from the word meaning "hint" or "trace." He exchanged paper for polycarbonate, preserving the translucency of the original while enhancing its durability and modernity.

The semi-transparent nature of the Kehai provides only a vague sense of the passage of time, transporting its viewer from the frantic present to a quieter, slower dimension. When so many of us are slaves to the clock and may find the mere presence of one depressing, the Kehai helps us relax over time's inexorable flow.

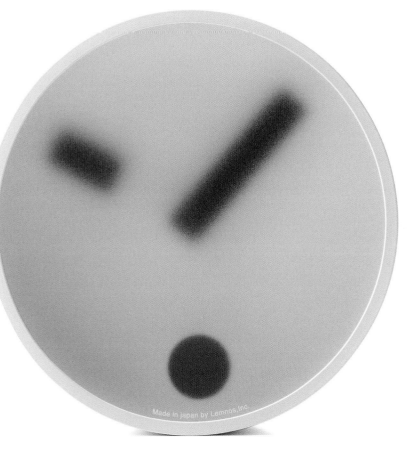

## Slip into This

**One Piece Slippers**, 2004, Naoko Hirota, ethylene-vinyl acetate, L11.2×W4.9×
H2.4inches (L28.4×W12.4×H6cm), NAOCA

The simplicity of this slipper belies its quality. It was created by designer Naoko Hirota, who took a single sheet of fabric and cut it in a die, folded the fabric over to make a heel, then sewed the toe portions together. It works beautifully: the foot slides in smoothly, the heel is well supported, and walking is easy.

Hirota's initial idea was to create a stylish, simple slipper for airline passenger use during long-distance flights. But in Japan, where shoes are never worn inside the home, these slippers also make for sensible, modern housewear.

Until recently, the trend for household slippers was for such shoes to be backless, to make for easy removal before the wearer stepped onto delicate, woven tatami mats (upon which any kind of footwear, including slippers, is forbidden). Recently, however, many consumers have tired of their ungainliness, as well as the slapping noise made by such footwear on wooden flooring. Coupled with the decrease in tatami-mat rooms, indoor shoes with covered heels are increasingly popular.

For inspiration, Hirota drew upon the traditional Japanese toe-socks known as *tabi*, which she had always admired for their simplicity, functionality, and comfort. She was delighted when, upon seeing her one-piece slippers for the first time, many wearers commented on their similarity to tabi, confirming the continuing Japanese regard for dressing feet in beautiful, dignified footwear.

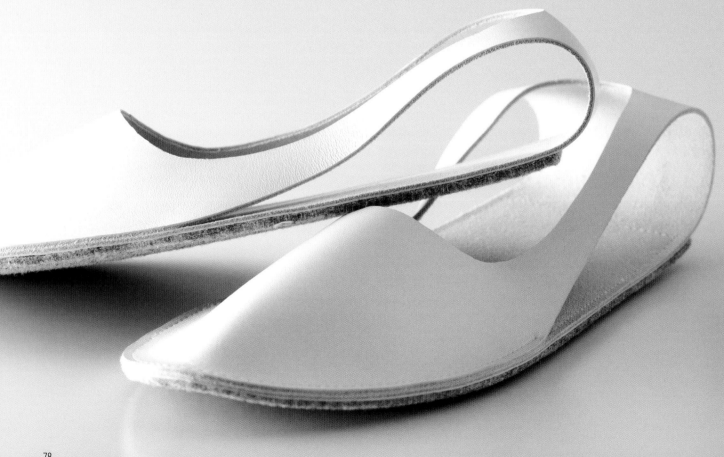

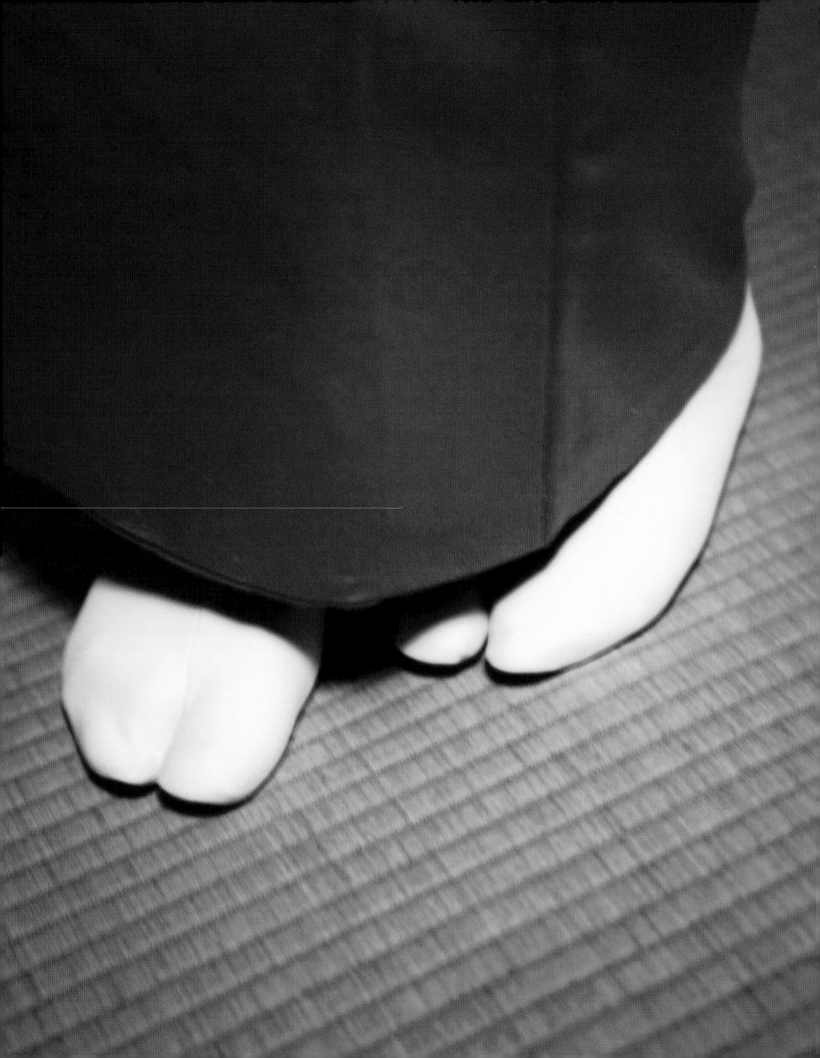

## Memory Bundle

**Furoshiki**, 2000, 9brand, nylon, 23×23×0.2inches (59×59×0.5cm), 9brand

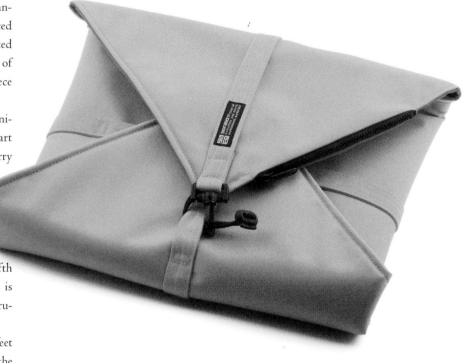

A furoshiki is a single piece of fabric, used in Japan since ancient times to wrap and carry objects such as gifts. While known to every Japanese, there was a danger of it becoming extinct in this age of mass-produced bags, until its environmentally-friendly features attracted renewed interest. The husband-and-wife design team of Keita and Naoyo Seto created Furoshiki, a tailored piece of fabric for wrapping breakable items, in this vein.

They were inspired by Keita's memories of his university days, when he would carefully wrap valuable art books from the library in a thick sweatshirt and carry them home. Their idea for the Furoshiki came from a search for a way to safely and efficiently carry a laptop computer—a highly valuable object, just like the art books. While the traditional furoshiki is typically made of thin fabric, their version employs cordura nylon, filled with one-fifth inch-thick, shock-absorbent urethane. The Furoshiki is sturdy enough to carry laptops and other fragile instruments, yet is soft to the touch and pleasing to the eye.

They set the size of the Furoshiki at about two feet square. An adjustable belt and hook mechanism fixes the cloth in place, and a pocket accommodates peripherals, such as a mouse or cord.

The Furoshiki debuted in 2000 as part of the 9brand project that they established in 1999. The theme of 9brand is "Evolution of Life," and with Furoshiki, they have helped the traditional cloth evolve into a tool for the digital age.

**Pen Tray**, 2005, Hiroshi Yamasaki, lacquer, 3.3×7.3×1.4inches (8.5×18.5×3.5cm),
Wajima Kirimoto

This lacquered pen tray by Hiroshi Yamasaki resembles an old-fashioned, artisan-crafted writing box, used for storing an ink stone or ink cake. It is stylish enough, however, to complement any contemporary office space.

Yamasaki specializes in stationery goods, and his policy when seeking inspiration is to visit manufacturing sites and observe particular craftsmen. He then designs products with their skills in mind. The pen tray came to life after he was approached by Taiichi Kirimoto, of Wajima Kirimoto, a woodwork company in the famous Japanese lacquerware region of Wajima dedicated to rejuvenating lacquerware's somewhat serious image. Kirimoto told Yamasaki that his ambition was to associate lacquerware with more approachable, everyday objects—such as tableware, stationery, flooring, and doors. Yamasaki was intrigued with the idea and, since Wajima Kirimoto's specialty is high-precision woodwork, he began thinking along those lines.

"I was aiming for an extremely simple shape with as few parts as possible," he says. "I don't really like objects that are purely decorative, so I wanted to make the object's use obvious from its shape."

The exterior of the tray is coated with wipe-lacquer, while the interior is finished in the scratchproof *makiji* style. The interior is raked, so that pens can easily be retrieved. The tray lacks any fancy embellishment, yet effuses a dignified, high-quality aura.

In merging the traditional with the modern, Yamasaki's design signals a new era for lacquerware—one that is focused less upon the fine-art objects of the past and more upon tools that are practical and beautiful, for the present and future.

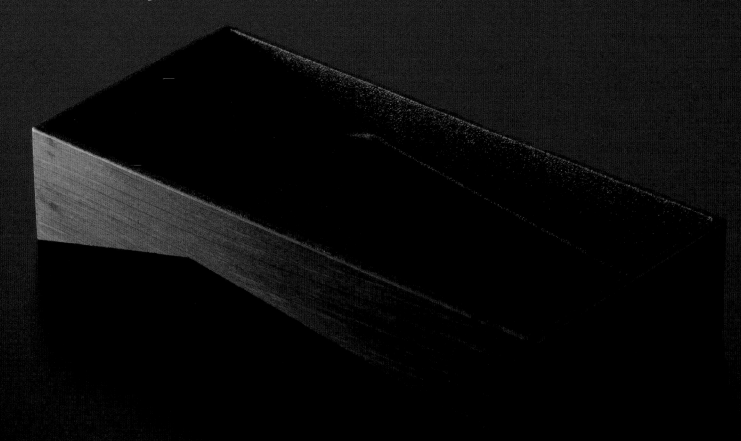

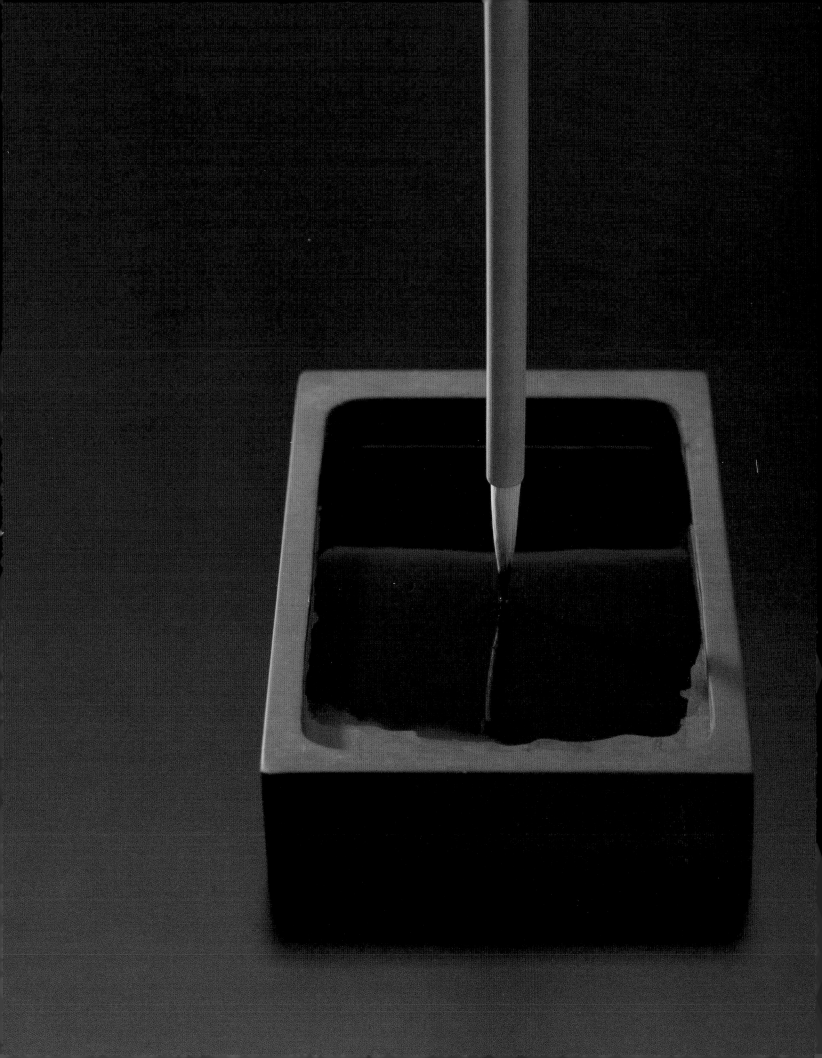

## Playing for Keeps

**Trash Pot**, paper garbage box, 2004, Drill Design, paper, Φ7.8× H11.4inches (Φ20×H29cm), TAMU

In 2004, the three young designers of Drill Design received a request from a packaging manufacturer for a paper trash can. Rather than take the obvious tack of creating a disposable object, the designers envisaged creating a product that would have a long life, despite its fragile material. They glued two paper tubes together, curled the edges to increase longitudinal strength, and added precise finishing touches to increase value. They named their creation, a cross between an oversized ice cream carton and a flowerpot, the Trash Pot.

Paper has a long and venerable history in the lives of the Japanese, yet recently its image seems to have declined, from that of a valuable material for use in screens and sliding doors, to something cheap, disposable, and flimsy. With the Trash Pot, the designers of Drill Design wanted to restore paper to its former glory.

In creating the Trash Pot, the designers started at the very beginning: the six-mat tatami room, a standard Japanese room size of about one-hundred square feet, found in almost all modern homes. The designers felt that a compact trash can, more suited to this size of room, may also be valued as a personal possession—one for each member of the family, you might say. To enhance this sense of individuality, the Trash Pot was produced in a range of five colors, although tranquil tones suited to Japanese homes were favored over louder colors.

As one of the finishing touches, the designers made the trash can with a two-ply structure to conceal a plastic supermarket bag or the like used as a liner. The resulting product is elegant and inconspicuous, stylish and highly practical, reminiscent of a decorative vase.

# The Box Seat

**Riki Stool**, 1965, Riki Watanabe, copartner: Q designers, cardboard, large: H16.5×D13.0inches (H42×D33cm), small: H13.0×D13.0inches (H33.2×D33cm), Jujo Seishi Co., Ltd. (Reproduct: YOS Collection, 1997)

Born in 1911, Riki Watanabe has been hailed as a pioneer of postwar Japanese design. He first conceived of creating cardboard furniture in 1965, when cardboard was neither cheap nor commonplace. Watanabe felt it held promise, with its strength and low weight, as material for a child's seat. His Riki Stool was well received, but the high cost of cardboard at the time prohibited mass production.

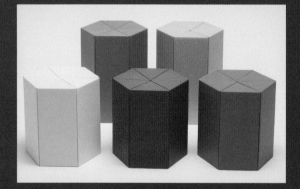

Over thirty years later, in 1997, Watanabe resurrected the seat as part of a recycling project. The hexagonal Riki Stool is extremely light and strong, being able to withstand static loads of up to 409lbs. It is available in two heights and four colors—red, blue, yellow, and white—and comprises a total of fourteen die-cut parts that are easily assembled. With its simplicity and reasonable price, the Riki Stool has become a much-loved long seller.

Watanabe was fifty-four when he made his prototype Riki Stool, which finally reached store shelves when he was eighty-six. It is testament to his determination to create timeless products, leaving as little waste as possible, that the idea for this seemingly fragile but deceptively strong stool has survived for so long and continues to influence designers today.

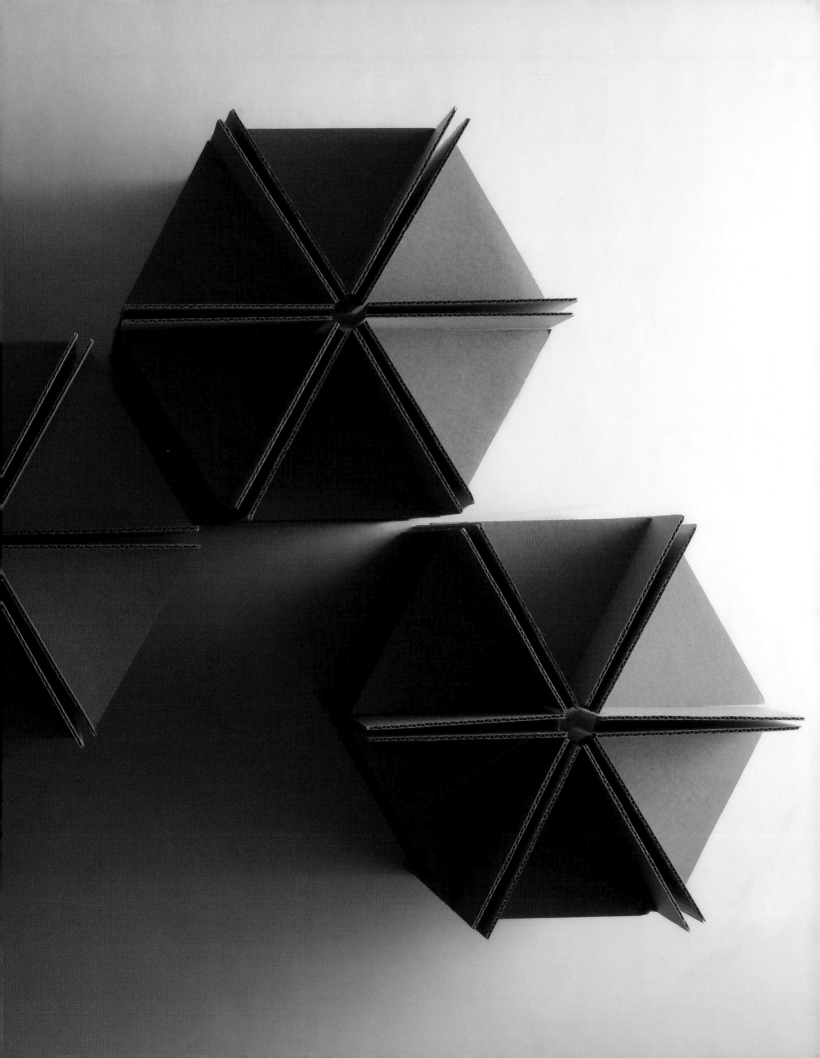

## The Rubber Menagerie

**Animal Rubber Band**, 2002, Passkey Design, silicone, various dimensions, H Concept Co., Ltd.

Transforming a humble rubber band into an object of affection is no easy task, but with Animal Rubber Band—a colorful circus of animal-shaped rings—Yumiko Ohashi and Masanori Haneda of Passkey Design have created a product to make anyone think twice before throwing it away.

With a lineup ranging from rabbits to elephants, and from kangaroos to ostriches, the bands function as regular rubber bands when stretched, but when relaxed snap back to their original zoological shape.

To realize their vision, the designers made hundreds of line drawings, simplifying the features and varying the colors of each animal to make it recognizable to even the smallest child. They selected silicone as the material, which deteriorates more slowly than natural rubber. (Silicone bands are more expensive than common would make it even more difficult for people to part with them.)

Ohashi and Haneda began their careers as in-house designers for a consumer electrics maker before founding Passkey in 1995. Over the years, they have garnered no less than eleven prizes in design competitions, among them—for the Animal Rubber Band—the 1999 Shachihata New Product Design Competition. Unfortunately, Shachihata Inc. decided against commercialization of the product, but the animals found a home in 2002, when a company called H Concept agreed to put them on sale.

It is difficult not to admire Ohashi and Haneda, not only for their vision in transforming the rubber band, but also for their tenacity in seeing their idea through to commercial realization. As a result, Animal Rubber Band has wormed its way into the affection of a great many people.

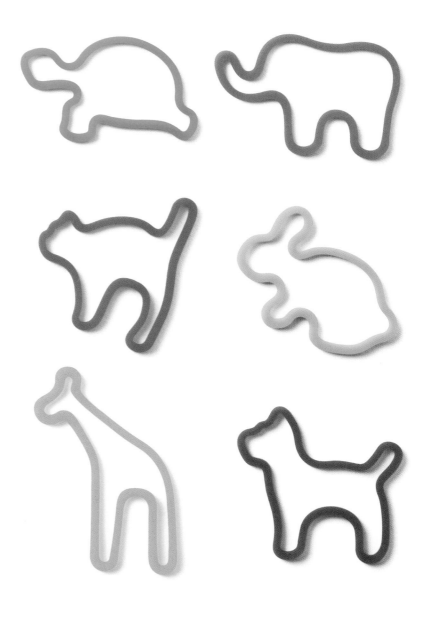

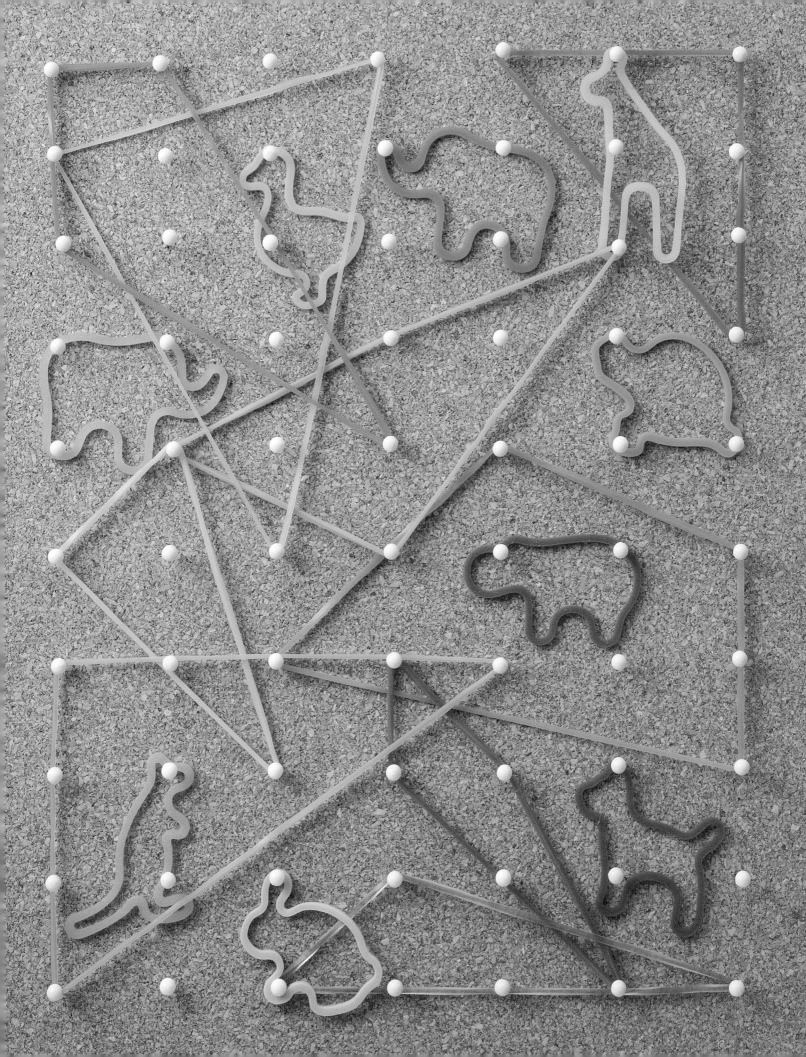

## Inside Is Out

Splash, umbrella stand, 2003, Yasuhiro Asano, rubber (11 color variations—
black, blue, gray, orange, red, brown, off-white, green, pink, light blue, yellow),
W5.5×D6.1×H3.8inches (W14×D15.5×H9.6cm), weight 42.3ounces (1200g), H
Concept Co., Ltd.

Yasuhiro Asano has long been fascinated by shapes that appear to reverse when viewed for a long time. He also developed an interest in topology and the Theory of Relativity. Asano's Splash umbrella stand gives concrete form to such fascinations: on first glance, it is quite impossible to tell Splash's top from bottom, or front from back, let alone the object's purpose—and yet we are impressed by its uniqueness and its reassuring weight.

Asano says the defining feature of Splash is its ability to hold wet and dry umbrellas separately, the former in the stand's protrusions and the latter in its indentations. Splash is also playful: the outside intrudes upon the inside, until eventually, the outside *becomes* the inside.

Asano first entered Splash in Toyama Product Design Competition 2002, where it won the Toyama Design Prize. He intended to manufacture it in aluminum, but on learning the project was not suited to mass production, found himself at a dead end. It was Hideyoshi Nagoya of H Concept, a manufacturing enterprise that assists designers to develop novel products, who suggested he try rubber, a material that can be molded integrally while maintaining all-important weight, and can be dyed an array of colors. Nagoya also coined the name Splash, on noting that the object has the appearance of splattered water.

Unfortunately, the development process has been difficult: removing such a complex shape from its mold requires an intricate operation performed by skilled workers, and hence Asano's dream of mass production has yet to be fulfilled. But as the project continues, Splash stands as a symbol of cooperation between a designer's pursuit of a unique vision and a manufacturer's will to realize it.

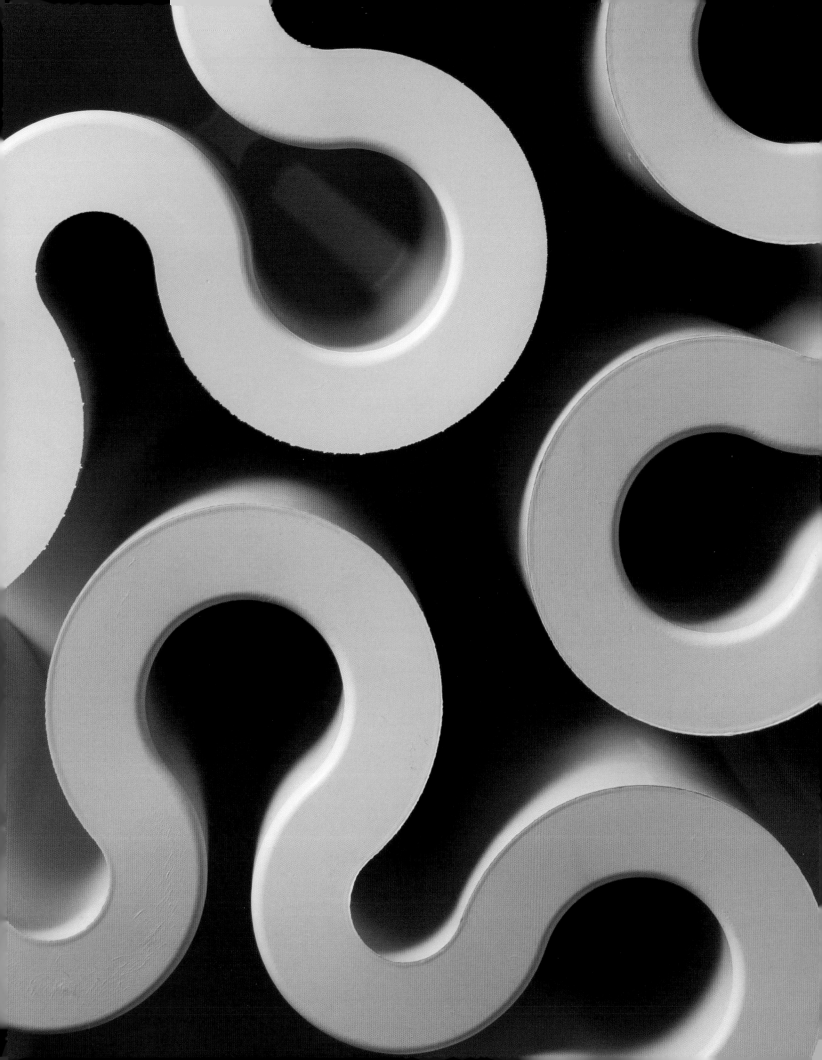

# Fleet of Foot

**Aquarium #003**, shoehorn, 2002, Shinichi Sumikawa, aluminum, L13.0×1.2×1.2inches (L33×3×3cm), Takenaka Works Co., Ltd.

Japanese homes are strictly shoe-free zones, so it follows that in the *genkan*—the anteroom between the front door and the rest of the house, used for removing and putting on footwear—the most commonly found tool is the shoehorn.

Designer Shinichi Sumikawa says he long found it curious that such a essential implement had rarely enjoyed the attentions of a rigorous design process. He wanted to create a shoehorn that could be admired as a thing of beauty, enhancing the entranceway even when not in use. The resulting Aquarium, created from three-dimensional computer images, is a sculpture in its own right.

As its name suggests, the Aquarium reflects the functional beauty of a fish, its smooth, flowing lines perhaps conjuring images of a swordfish cutting effortlessly through water.

The effect is emphasized by the Aquarium's aluminum mirrored surface, created by the Takenaka Works Company in Takaoka, a city in Toyama Prefecture famed for its cast metal. Highly skilled craftsmen produce the surface, simply through polishing. No coating or other processing takes place, and since only 100-percent pure aluminum is used, scratches can simply be polished away. And at the end of its life, the shoehorn can be recycled.

Sumikawa's biggest hope for the Aquarium was to create a tool that would allow the foot to slide comfortably into its shoe in a moment of great aesthetic pleasure. It is no exaggeration to say the Aquarium has transformed genkan throughout Japan.

## A Southern Star

**The Tsubame**, bullet train, 2004, Eiji Mitooka, body: aluminum double skin structure, LEAD CARRIAGE LENGTH: 89.7feet (27.35m), CARRIAGE LENGTH: 82.0feet (25m), body width: 11.1feet (3.38m), body height: 11.9feet (3.65m), Hitachi, Ltd.

When the Japan Rail Kyushu corporation announced the commission of a new Shinkansen "bullet train" to service Japan's southernmost main island of Kyushu, residents of the island were thrilled. The "*Tsubame*," meaning "swallow," would be the first bullet train to cross their region. The residents' anticipation rose when the train's designer asked to consult with them directly: they were impressed that he wanted to hear what they wanted the train to be.

According to the designer, Eiji Mitooka, who has created railroad vehicles and train stations and has a long association with Kyushu: "A designer should not simply express his ideas, but should stand in his customer's shoes and translate their wishes into usable objects."

From his discussions, Mitooka learned that the residents wanted a train that would reflect their identity, both as Japanese and as locals of Kyushu. He then studied the 0 Series Shinkansen, the first "super-train" that amazed the world in 1964, when it zoomed across Japan at record speeds. He recalled his excitement as a young man on his

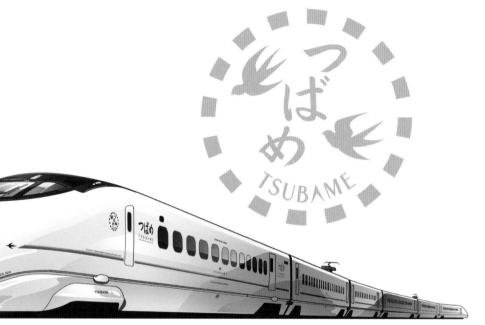

first Shinkansen journey, and wanted to recapture that sense of wonder, coupled with pride in the technology of his home country.

At his drawing board, Mitooka reconfigured the unpopular "duckbill" nose of the modern 700 Series into a smooth, long nose. Next, he convinced his clientele that the almost-pure white of the body, which had been criticized for its tendency to look dirty, should be made even whiter, rather than toned down to enable easy cleaning. He painted red and gold lines on the side of the body to impart a sense of speed, and for contrasting tranquility, colored the roof in black and brown tones reminiscent of Japanese lacquerware. The finished body echoed the origins of the Shinkansen.

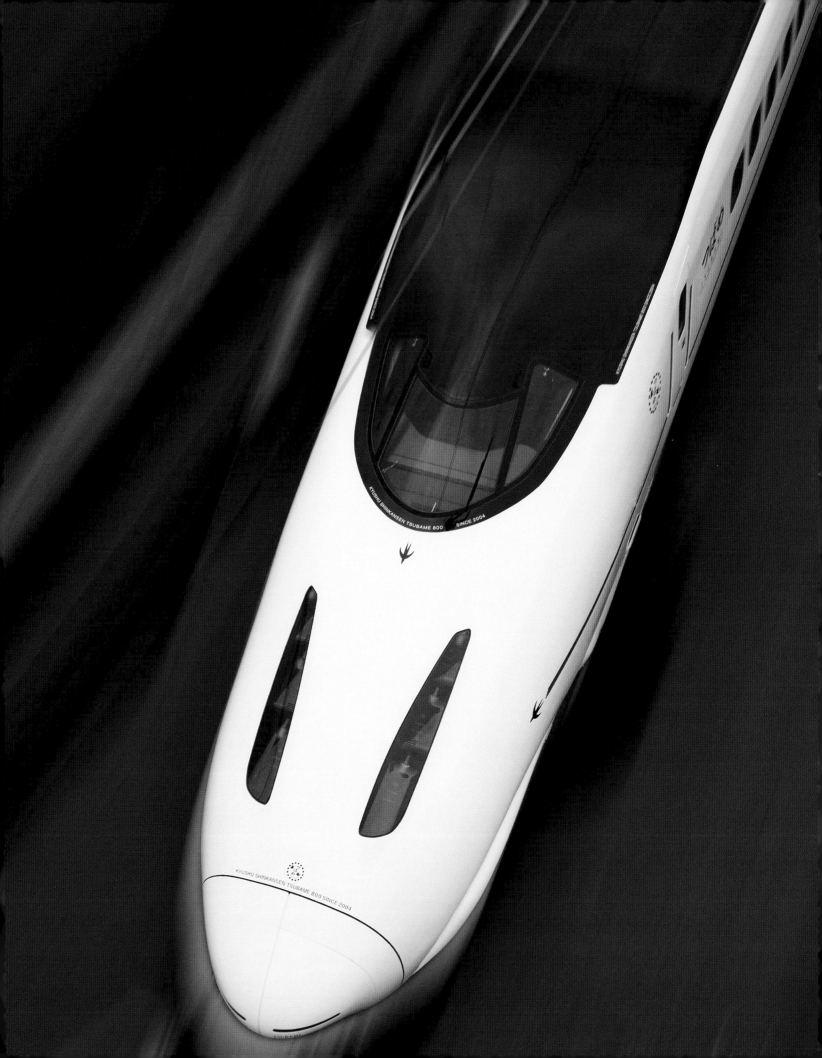

For the interior, Mitooka insisted that natural materials in traditional colors be used as much as possible. High-backed chairs made of wood and upholstered in *nishijin* brocade provide every passenger with a personal space; the windows are shaded by blinds decorated with a cherry blossom pattern; *noren* curtains made of *igusa* rush hang in front of the washrooms. He employed local talent at all stages of the interior design, and his attention to detail, along with his doggedness, moved all those involved in the Tsubame's development.

Mitooka believes that public spaces should be subject to the highest design standards and furnished with the best quality materials. "If the end product is good," he says, "it will be used with care." He also believes that designers must be conscious of the era and location in which they are working and simultaneously strive to raise the bar on worldwide design standards. With the success of the Tsubame, he has contributed to the revitalization of the Kyushu economy while honoring its culture and traditions.

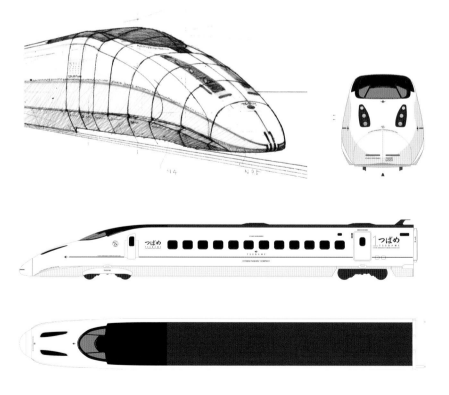

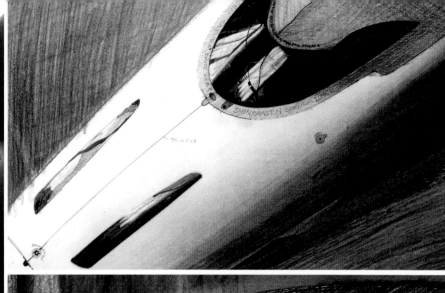
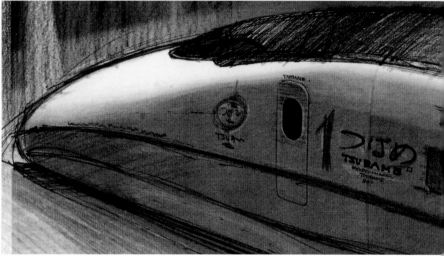

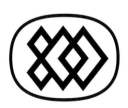

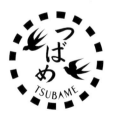

TSUBAME

TSUBAME

## Easy Rider

**Super Cub C100**, 1958, total emissions 49cc, L70.1×W22.6× H37.2inches (L178×W57.5×H94.5cm), Honda Motor Co., Ltd. PAGES 98–99: Super Cub50 (standard), 2002–, total emissions 49cc, L70.8× W25.9×H39.7inches (L180×W66×H101cm)

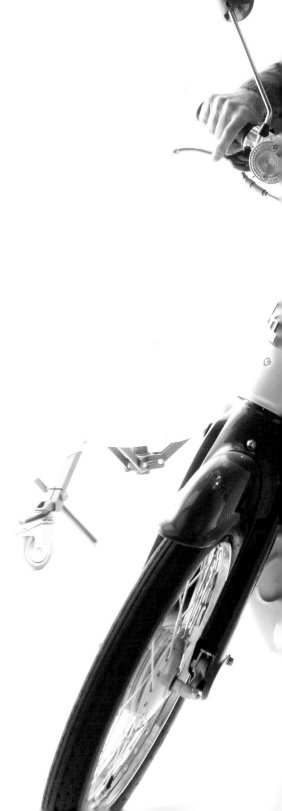

The Honda Super Cub has sold over fifty *million* units since its launch in 1958. What is it about this design that drives such phenomenal popularity?

After World War II, Honda produced the widely popular Cub F, an auxiliary engine that could be attached to bicycles (below). But with Japan's spectacular economic growth of the 1950s, consumers demanded a new type of two-wheeled machine—one that could handle Japan's still-poor roads and be ridden by experienced and new riders alike.

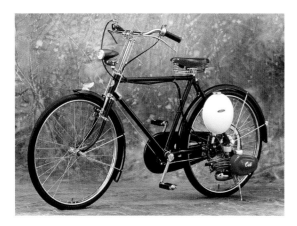

Soichiro Honda, the founder of the Honda Motor Company, set his mind on creating a "completely new 50cc bike, neither a motorbike nor a scooter." With this simple brief, his staff began a long process of test production. Their aim was to create a vehicle with enough horsepower and legroom to handle unpaved roads, sufficient maneuverability for a noodle delivery boy to drive with one hand while carrying his goods in the other, and enough style for a woman to drive while wearing a skirt.

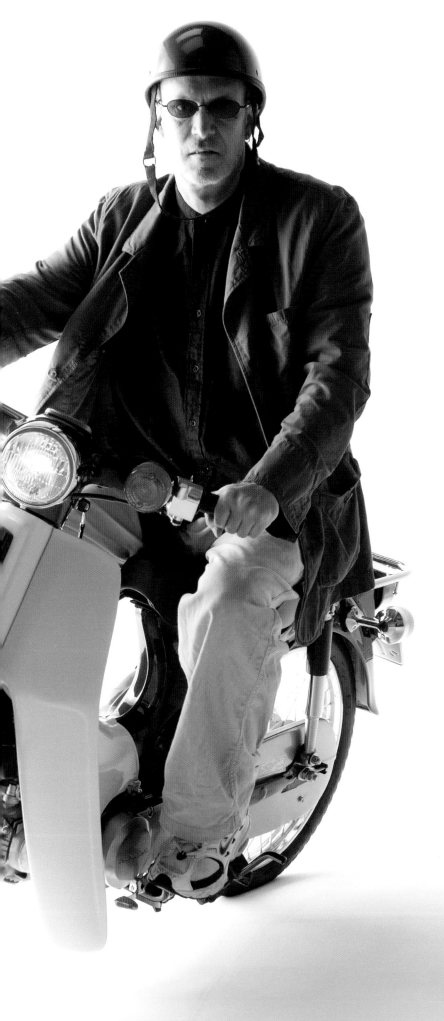

Their efforts resulted in a clean, energy-efficient, 4.5 horsepower, four-cycle engine. The bike handled comfortably, with excellent steering stability and 17-inch tires, and an automatic centrifugal clutch enabled the rider to shift gears by simply stepping on a pedal. The fuel tank was positioned below the seat to increase legroom, and the engine was placed low to the ground. A polyethylene front fairing kept weight down and softened the bike's image.

The simple design resulted in an almost indestructible machine, and the Super Cub C100 attained a previously unknown ubiquity, truly satisfying demands for a bike that could be ridden by anyone, almost anywhere. Of course, Honda has created many new Super Cub models since 1958, but the basic design, loved all over the world, remains unchanged.

## Gas and More

**Prius**, 1997–May 2000, 14.0feet (4.275m) length, interior dimensions: 6.1feet (1.85m) length, 4.1feet (1.25m) height, Toyota Motor Corporation

The Prius is the first "car of the future" to hit the mass market, a revolutionary attempt to sate our undying demand for cars while alleviating the environmental damage they cause.

Toyota began developing the Prius in 1993, with the goal of halving the fuel consumption of a conventional car of the same class. The result was a completely new "hybrid" system, in which both a gasoline engine and an electric motor provide momentum, depending on driving conditions. The car is started using battery power and initially travels on the electric motor alone. After reaching a certain speed, the engine and motor are used in conjunction, and for sudden acceleration, the battery provides additional power. During braking and deceleration, the motor functions as a generator, converting kinetic energy into electricity that is stored. A computer controls the interplay between the electric motor and gasoline engine.

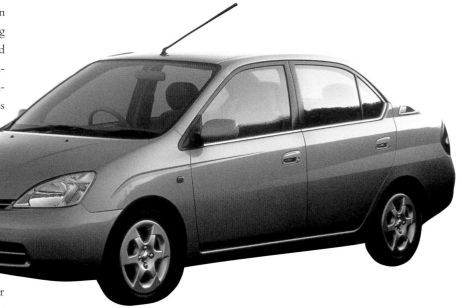

Having developed its hybrid system, Toyota launched an in-house design competition to determine a suitable shape for the car. The winning design was for a conventional "three-box" sedan, comprising an engine compartment, a cabin, and a trunk. However, by raising the height of the cabin and sculpting the three boxes to appear integrated, the Prius was given unique contours. Such attention to detail is also evident in the interior, where, for example, the dashboard meters are grouped together in a central position for easy reading.

As people become more aware of the need to balance economic development with environmental consciousness, the Prius provides the convenience of a standard automobile while showing the way for sustainable transport. Futuristic yet practical, it exemplifies the positive synergy between Japanese technology and design.

## Happiness Is a Warm TV

**AQUOS C1**, LCD TV, 2001, Toshiyuki Kita, plastic, [15inch type]
17.2×14.5×7.8inches (43.7×36.9×19.8cm), Sharp Corporation

In 1999, when electronics manufacturer Sharp commissioned Toshiyuki Kita to build the definitive liquid crystal television, he was determined to create something completely original, an appliance that would stand apart from its competitors and open a new path for Japanese product design.

In contrast to the cold and steely LCD televisions of the time, Kita dreamt of a TV that brought warmth to the home and blended with the interior like a piece of furniture. His first innovation was to create a small flat-screen television in the shape of a bag, complete with a handle for portability. For stability, he adopted the boomerang-shaped legs he employed in some of his other furniture designs. On these, he mounted the main body of the television so that it could freely rotate and tilt, enabling viewing from any angle. Large speakers were located on the front surface, providing a focal point for the design as well as fine sound quality.

Despite the futuristic result, Kita's work contains elements of Japan's traditional crafts. Lacquerware techniques contributed to the multi-layer coating on the leg portion, while the difficult curved edges of the main body reflect a superb attention to detail. This is the quintessential Japanese mix of design and manufacturing—finished to the last millimeter, and mating high-tech with high style.

In testament to its designer's international sensibility, the Aquos enjoys great popularity overseas as well as at home. Soon after going on sale, it was added to the permanent collections of the State Museum of Modern Art in Munich, and the Hamburg Museum of Art and Craft, confirming its status as an international benchmark for flat-screen televisions.

SHARP
LC-15C1A

# DESIGNER PROFILES

## The Butterfly Stool
## Sori Yanagi

Sori Yanagi was born in Tokyo in 1915, and graduated in fine art from Tokyo National University of Fine Arts and Music. In 1940, he accompanied Charlotte Perriand on her tour of Japan and participated in the Perriand Exhibition the following year. In 1942 he entered the Junzo Sakakura Architecture Institute, and in 1952 he won First Prize for his record player in the first ever industrial design contest to be held in Japan. 1953 saw the founding of the Yanagi Design Institute, and two years later, he began teaching as a professor at Kanazawa College of Art. In 1977 he was awarded the directorship of the Japan Folk Crafts Museum Tokyo.

Yanagi won the gold medal at the inaugural Milano Trienniale in 1957. He exhibited at Documenta 3, Kassel in 1964, and a one-man exhibition of his work was held in 1980 at the Pavilion of Modern Art in Milan, Italy. He was honored as a Person of Cultural Merit by the Japanese Government in 2002.

Yanagi is active in a wide range of design fields including furniture. His best known works are the Butterfly Stool and the Elephant Stool (1954), tableware such as his white porcelain teapot of 1956 and his cutlery series of 1982, and public design projects such as soundproof barriers for expressways, and even an Olympic cauldron.

For inquiries regarding the Butterfly Stool, contact: Tendo Co., Ltd.
E-mail: info@tendo-mokko.co.jp
Website: www.tendo-mokko.co.jp

## The Midori Chair
## Midori Mitsui

After graduating from the industrial design department of Tokyo National University of Fine Arts and Music in 1963, Mitsui traveled to Denmark to study furniture design at the Royal Danish Academy of Fine Arts under Poul Kjærhorm. In 1975 she founded Mitsui Midori Design and since then has worked toward creating durable and lovable pieces of furniture. In 1998, her M Chair won top prize at the inaugural Wooden Chairs for Living Exhibition, and in 2000 she won the prize again with her Hanaco dining chair. 2005 saw the release of her Midori Chair, an updated version of the M Chair.

Contact: Midori Mitsui
26-12 Nishimine-machi, Ota-ku, Tokyo, Japan 145-0075
Tel: +81-3-3756-4446
Fax: +81-3-3756-4530

## Tango Chest 120
## Hisae Igarashi

Igarashi graduated with a degree in interior design from Kuwasawa Design School. She worked at Kuramata Design Office from 1986 to 1991, and in 1993 founded the Igarashi Design Studio. She has produced store designs for Tsumori Chisato and others, and is currently involved in a wide range of projects centering on living space and product design. She is a part-time lecturer at Kuwasawa Design School and a member of the Good Design Award judging committee.

Contact: Igarashi design studio
RGS-3B 7-44-6 Takinogawa, Kita-ku, Tokyo, Japan 114-0023
E-mail: homepage@igarashidesign.jp
Website: www.igarashidesign.jp

## ToFU
## Tokujin Yoshioka

Yoshioka was born in 1967. After studying design under Shiro Kuramata and Issey Miyake, he founded Tokujin Yoshioka Design in 2000.

Over a period of almost twenty years, Yoshioka collaborated on many projects with Issey Miyake, including store designs for the Issey Miyake and A-Poc brands, and installations for an exhibition entitled "Issey Miyake Making Things," which was held at the Cartier Foundation in Paris. This work received high praise from overseas.

At the Milano Salone del Mobile in 2002, Yoshioka unveiled his paper chair Honey-pop and the Tokyo-pop chair manufactured by Driade. He also designed an installation for the *da*driade showroom, transforming the entire space into a futuristic Japanese Garden.

His other designs include Yamagiwa's lighting fixture ToFU and a futuristic chandelier designed for Swarovski Crystal Palace entitled Stardust.

Yoshioka presented his Pane chair at the Milano Salone del Mobile in 2006. The production method for this piece follows almost exactly the steps required to bake bread. Through the application of heat, the fibers constituting the chair memorize its shape. Yoshioka is renowned as a designer who always undertakes experimental designs in pursuit of new possibilities for the future.

Yoshioka has received a number of awards, and his works can be found in the permanent collections of MoMA, the Center Pompidou, the Vitra Design Museum, and the Victoria and Albert Museum.

Contact: Tokujin Yoshioka Design
E-mail: tyd@tokujin.com
Website: www.tokujin.com
For product inquiries: Yamagiwa LIVINA
TEL: +81-3-3253-5111
Website: www.yamagiwa.co.jp

## The Sumitsubo
## Makoto Koizumi

Makoto Koizumi was born in Tokyo in 1960. After studying under Choei Hara and Shigemitsu Hara, he established his own design studio in 1990. He is involved in all fields of design, from small household items such as chopstick rests to furniture and even architecture. In 2003 he opened the Koizumi Douguten in Kunitachi, Tokyo as a space for introducing the general public to the design world. His publications include "Design Elements" (2003) and "To/To" (2005). In 2005 he became a professor in

the Scenography, Display, and Fashion Design department of Musashino Art University.

Contact:
Koizumi Studio
2-2-5-104, Fujimidai, Kunitachi-shi, Tokyo, Japan 186-0003
Tel: +81-42-574-1458
Fax: +81-42-575-3646

Koizumi Douguten
Tel: +81-42-574-1464
Website: www.koizumi-studio.jp

PAGES 32–33
## METAPHYS/Hono
## Chiaki Murata

Chiaki Murata joined Sanyo Electric Co., Ltd. after graduating from the Faculty of Engineering at Osaka City University in 1982. During his time at Sanyo, he was involved in product design and the development of new projects such as domestic appliances for one-person households.

He founded Hers Experimental Design Laboratory Inc. in 1986, and since then has been working as a designer in a vast range of fields including graphics, C.I., interface design, and, of course, product design. In 2005, he designed the console of Microsoft's Xbox360. At a press release in July, 2005, he announced a consortium design brand Metaphys, which has won a great deal of media coverage as a novel cross-industrial business model whereby corporations are united under a shared design philosophy.

He is the managing Director of Hers Experimental Design Laboratory, Inc., and a lecturer at Tama Art University

Contact: Hers Experimental Design Laboratory, Inc.
Osaka Head Office, 1-5-22 Mukogaoka, Toyonaka-shi, Osaka, Japan 560-0053
Tel: +81-6-6854-5963
Fax: +81-6-6854-3386
E-mail: info@metaphys.jp
Website: www.metaphys.jp

PAGES 34–35
## Coro-Hako
## Katsushi Nagumo

Nagumo graduated from Tokyo Zokei University with a degree in Interior Architectural Design in 1979. After working for Jo Nagahara Design & Associates, he formed the Nagumo Design Office in 1987. He works mainly in the fields of furniture and landscape design. Awards won include the Good Design Award in Environmental Design, the Good Design Award Gold Prize for Furniture & Interiors, and the Civil Engineering Grand Prize.

Contact: NAGUMO DESIGN
2F, 1-10-3 Hatagaya, Shibuya-ku, Tokyo, Japan 151-0072
Tel: +81-3-5333-8590
Fax +81-3-5333-8591
E-mail: nagumo@nagumo-design.com
Website: www.nagumo-design.com

PAGES 36–37
## The Hamburger Stool
## Makoto Koizumi    (PAGES 28–31  The Sumitsubo)

PAGES 38–39
## Oba-Q (K Series)
## Shiro Kuramata

Kuramata was born in Tokyo in 1934. He graduated from Kuwasawa Institute of Design in 1956 and established the Kuramata Design Office in 1965.

He received the Mainichi Industrial Design Award in 1972 and the Japan Cultural Design Award in 1981. In the same year he joined Memphis in Milan, Italy. He was awarded the Ordre des Arts et des Lettres by the French Government in 1990. He died in 1991.

His outstanding works include his Furniture in Irregular Forms "Side 1, Side 2", (1970), which can be found in the permanent collections of MoMA and many other museums worldwide, his steel mesh chair "How High the Moon" (1986), his acrylic/artificial roses chair "Miss Blanche" (1988).

Contact for product inquiries: Yamagiwa LIVINA
Tel: +81-3-3253-5111
Website: www.yamagiwa.co.jp

PAGES 40–41
## The Teiza-isu
## Daisaku Choh

Daisaku Choh was born in Manchuria in 1921. He graduated in architecture from Tokyo National University of Fine Arts and Music, and in 1947 entered the Junzo Sakakura Architecture Institute, where he worked on residential design projects while supervising the furniture design department of the firm.

In 1972 he established his own Architectural Design Laboratory to continue his work in the fields of residential and furniture design. His works since then include the Teiza-isu, the Triangular Stool (1996), and the Small Chair (1953). He has received a number of awards and prizes including the Good Design Award and the Japan Interior Designer's Association Award.

Teiza-isu contact: Tendo Co., Ltd.
E-mail: info@tendo-mokko.co.jp
Website: www.tendo-mokko.co.jp
Persimmon chair contact: Metropolitan Gallery Inc.
E-mail: metro@cello.ocn.ne.jp
Website: www.metropolitan.co.jp

PAGES 42–43
## Akari
## Isamu Noguchi

Isamu Noguchi was born in Los Angeles in 1904 to a Japanese poet father and an American writer mother. He spent his childhood in Japan, and at the age of thirteen, he returned the U.S.A. alone. While studying medicine at Colombia University, he began to learn sculpture at art school. In 1927 he moved to Paris on a scholarship to further his sculpture studies under Constantin Brancusi.

In the early 1930s, he studied ceramics in Japan and ink brush technique in Peking. After returning to America, he began to widen the scope of his design work to include public spaces and monuments, parks, stage sets, furniture, and lighting. In 1950, he moved back to Japan, but continued to travel frequently to the U.S.

In 1969, Noguchi established a studio in the town of Mure in Kagawa Prefecture. 1985 saw the opening of the Noguchi Museum in Long Island

City, New York, and in 1987, he was presented with the National Medal of Arts by President Ronald Reagan. He died in New York in 1988.

Contact: The Noguchi Museum
32-37 Vernon Boulevard, Long Island City, New York 11106
Tel: 718-204-7088
Fax: 718-278-2348
E-mail: info@noguchi.org
Contact in Japan: Yamagiwa LIVINA
Tel: +81-3-3253-5111
Website: www.yamagiwa.co.jp

## The G-Type Soy Sauce Bottle

## The Shallow Rice bowl
## Masahiro Mori

Masahiro Mori was born in Saga Prefecture in 1927. Upon graduation from Tama Art University with a degree in craft design, he entered the Nagasaki Prefectural Ceramic Laboratory in 1954. Two years later, he moved to the Hakusan Porcelain Co., Ltd., where he was responsible for the design of pottery for mass production. In 1978, he established Mori Masahiro Industrial Design Laboratory.

His designs, which are firmly focused on everyday use and factory production, have won many prizes at home and abroad. His G-Type Soy Sauce Bottle won the first ever Good Design Award in 1960.

Over the years, he held teaching positions at Kyushu Industrial University, at the Department of Ceramics of Aichi Prefectural University of Fine Arts, and Saga Prefectural Arita College of Ceramics. From 1961 to 2004, over one hundred pieces of his work received recognition under the G-Mark system of the Ministry of International Trade and Industry; of those pieces, thirty received the G-Mark Long-Life Award. He died in 2005.

Contact: design-mori. connexion. Inc.
E-mail: mori@design-mori.co.jp
Website: www.design-mori.co.jp

## Tottotto
## Kazuhiko Tomita

Tomita was born in Nagasaki in 1965. He graduated in Industrial Design from Chiba University in 1989, and was awarded an MA from the RCA in London in 1992. His own concept brand "2.5-dimensional design" was established in 1993 in Milan. Tomita became an art director of Covo in 2000, and of Nussha in 2004.

He has studied under Yoshio Akioka, a trailblazer in the field of local craft development in Japan, and architect Vico Magistretti in Milan.

Tomita's major areas of design expertise are products targeted toward the world-wide market, including furniture and tableware. He constructs original brands by applying his wide knowledge of graphics. He has won many international awards for his works, including three Design Plus Awards at Frankfurt Messe.

Contact: 2.5-dimensional design
via montegrappa, 67 melegnano Milano 20077 Italy
Tel: +39-02-98232822
E-mail: my@tomitadesign.com
Website: www.tomitadesign.com

## ring ring
## Shin Nishibori

Nishibori was born in Gifu Prefecture in 1966. After nine years as an in-house designer at Matsushita Electric Industrial, he embarked on a freelance career. During his time as a freelancer, he designed products including the "ring ring," furniture and store interiors. He also ran the efish cafe in Kyoto. In 2002 he interrupted his career in Japan to travel to America, and is currently employed as a designer at Apple Computers.

Contact: Shin Nishbori
248 Amber Dr. San Francisco, CA94131
E-mail: shin@shinproducts.com
For product inquiries: Sfera s.r.l.
Studio CZ36, Viale Coni Zugna 36, 20144 Milano, Italy
Tel: +39-0262-694-344  Fax: +39-0289-052-249
E-mail: sferaeuro@ricordi-sfera.com
Website: www.ricordi-sfera.com
Contact in Japan: Ricordi & Sfera Co.,Ltd.
Tel: +81-75-532-1139  Fax: +81-75-532-1121

## Taketlery
## Takashi Ashitomi

In 1985, Ashitomi joined the Sony Design Center, where he was responsible for the design of TV sets, audio and visual equipment. In 1991, he established SAAT Design Inc.

Since 2002, he has been an associate professor of the Department of Product Design, Tama Art University, and a member of the judging committee for the Good Design Award, which is sponsored by the Japan Industrial Design Promotion Organization.

Recently he has been widening his approach to design, taking on projects related to the development of local industry, design education, and design criticism.

Contact: Takashi Ashitomi
E-mail: ashitomi@tamabi.ac.jp

## ZUTTO
## Fumie Shibata

After graduating from Musashino Art University in 1990, Shibata entered the Toshiba Design Center Corporation. She left Toshiba to establish a Tokyo-based design office, Design Studio S, where she has developed a base of specialty clients who employ her services for design projects ranging from communications to furniture, infant products and home appliances.

Shibata has received numerous prizes for her work, including the 1994, 2000, 2003, 2004, and 2005 Good Design Award, the Kainan Award at the Design Competition '96, the design award at the 1998 Design Wave in Toyama contest, the 1998 IF Product Design Award, the 1999 IF Kategorie of the year, and more. She is a member of the Japan Industrial Designer's Association, a member of the Judging Committee for the Good Design Award, and a part-time Lecturer at Tama Art University.

Contact: Design Studio S
2-6-15-502 Minami-Aoyama Garden Court
Minami-Aoyama, Minato-ku, Tokyo, Japan 107-0062
Tel: +81-3-5474-2305

Fax: +81-3-3479-7103
E-mail: info@design-ss.com
Website: www.design-ss.com

## Contrast/Aroma

### Ichiro Iwasaki

Iwasaki was born in Tokyo in 1965. After five years at the Sony Design Center, he moved to Italy in 1991 and worked as a designer in Milan. He returned to Japan in 1995 and established the Iwasaki Design Studio. His current design activities cover a broad range from IT devices to household goods such as tableware and furniture.

He is a lecturer on product design at Tama Art University and lecturer in the Department of Design, Tokyo National University of Fine Arts and Music. He is also a committee member for both the Good Design Award and the Auto Color Award.

Contact: Iwasaki Design Studio
E-mail: info@iwasaki-design-studio.net

## The Compact IH

### Kohei Nishiyama

Nishiyama was born in Hyogo in 1970 and lived in South America until the age of nineteen. He is a graduate of the University of Tokyo and the Kuwasawa Design School, where he studied product design. In 1997, he founded Elephant Design with a fellow pupil from design school to commercialize the DTO (Design To Order) system he invented, which reduces the risks of new product development by allowing manufacturers to wait until the number of orders for a product reaches a break-even point before committing to production.

Prior to the foundation of Elephant Design, he was a consultant at McKinsey & Co., where he primarily handled new product development projects. In 2002, Muji, a popular Japanese design lifestyle retailer, began to use the DTO system. Products developed by this system rank in the top three in Muji's sales revenues. Thanks to his widely recognized expertise in product development, he is now a design consultant for companies such as TEPCO.

Nishiyama has received several design awards, and he is presently CEO of Elephant Design Co., Ltd.

Contact:
Website: www.cuusoo.com/; www.elephant-design.com

## Boya

### Hiroshi Kajimoto

Hiroshi Kajimoto was born in Hyogo Prefecture in 1955.

After graduating in design from Tama Art University in 1979, Kajimoto began his career as a designer in a household appliances manufacturing firm.

In 1991, he founded Kajimoto Design, and since then has been involved mainly in the field of product design, creating kitchen tools, stationery, electrical appliances, IT devices, and so on. His best known works include the Bird kitchen scissors, the Ryodo stationery series, and his 3D frame.

He was awarded the Good Design Award in 2003, 2004, 2005, and the German IF Product Design Award in 2006. His works were exhibited at the 2003, 2004, and 2005 Milano Salone del Mobile.

He currently resides in Tokyo, where he is a part-time lecturer at both Tama Art University and Hosei University.

Contact: Hiroshi Kajimoto
5-7-11-702 Nishiogikita, Suginami-ku, Tokyo, Japan 167-0042
Tel & Fax: +81-3-5303-1386
E-mail: kajim@u01.gate01.com
Website: www.c-channel.com/c00526
For product inquiries: Kai Corporation
3-9-5 Iwamoto-cho, Chiyoda-ku, Tokyo, Japan 101-8586
Tel: +81-3-3862-6410
Website: www.rakuten.co.jp/kai-house/index.html

## Ken-on-kun

## Sweets

### Fumie Shibata    (PAGES 54–55  ZUTTO)

## IXY DIGITAL

Contact: Canon Inc. Canon Worldwide Network
www.canon.com

## The Walkman®

Contact: Sony Corporation
www.walkman.sony.co.jp

## MUTECH/telephone 610

### Ichiro Iwasaki    (PAGES 56–57  Contrast/Aroma)

## ALBA/Riki Watanabe Collection

### Riki Watanabe

Riki Watanabe was born in Tokyo in 1911. In 1936, he graduated from the Department of Woodwork at Tokyo Polytechnic High School and began to work in a store selling items designed and manufactured in Gunma under the supervision of German architect Bruno Taut. He established Riki Watanabe Design Studio in 1949.

In partnership with a group of young architects led by Kiyoshi Seike and Kenji Hirose, he began to focus his skills on residential and furniture design with the aim of creating modern living spaces. From 1952, he served as the first administration officer of the newly-founded Industrial Designer's Association, and is also a founding member of leading organizations such as the Japan Design Committee and the Craft Center Japan.

His Torii Stool and Round Center Table (1956) were awarded the Compasso d'Oro prize at the Milano Trienniale. Other outstanding works include the Rope chair (1952) and the Riki Clock (2003). He is also experienced in interior design, and was involved in the comprehensive renovation of the Prince Hotel chain.

Riki Collection Contact: Seiko Watch Corporation
www.seiko-watch.co.jp

PAGES 74–75

to:ca

## Koji Iwasaki

Iwasaki was born in 1965. In 1989 he began working for the Nishimura Design Studio and in 2002, he entered to:ca in the 2002 Asahikawa International Furniture Competition, where he won the Bronze Leaf Prize.

Contact: Nishimura Design Studio
3F, 21-1 Hakozaki-cho, Nihombashi, Chuo-ku, Tokyo, Japan 103-0015
Tel: +81-3-3664-9367
E-mail: nishimura-design@k8.dion.ne.jp
For product inquiries: www.idea-in.com/takumi/index.html

PAGES 76–77

kehai

## Makoto Koizumi    (PAGES 28–31  The Sumitsubo)

PAGES 78–79

One Piece Slippers

## Naoko Hirota

Born in Tokyo, Hirota graduated from Tokyo National University of Fine Arts and Music in 1990. In 1996, after several years of working at GK Planning & Design, she established her own practice, Hirota Design Studio. Her Naoca line of bags, which are created from the viewpoints of both fashion and product design, are available for purchase at museums such as MoMA and the Stedelijk Museum of Modern Art, Amsterdam.

In 1997 she exhibited at the Milano Salone del Mobile and held a private exhibition in Milan. In 1998-2000 she exhibited the Naoca Collection at the biannual Premiere Classe Paris.

In 1998 she was named the winner of the I.D. Annual Design Review, USA. She has also won a gold award in the Design Forum, Japan, the Good Design Award, and other prizes.

Contact: Hirota Design Studio
Tuttle bldg, 4F 2-6-5 Higashi-Azabu, Minato-ku, Tokyo, Japan 106-0044
Tel: +81-3-5545-4797
Fax: +81-3-5545-4798
E-mail: info@hirotadesign.com
Website: www.hirotadesign.com

PAGES 80–81

Furoshiki

## 9 brand

9brand is the design label of the husband-and-wife team of Keita and Naoyo Seto. According to the Buddhist worldview, the number nine represents the natural world enveloping all living things. With this philosophy in mind, 9brand was launched on the ninth day of the ninth month in 1999. The concept underpinning the label's product design and manufacturing is "design learned from living things." Since ancient times people have looked to the creatures closest to them, studied their shapes and modes of life, and incorporated these into their own lives. In recognition of this universal facet of human behavior, 9brand looks at living things from the perspectives of biology and natural history to evolve a new kind of design that uses all living things, both human and animal, as sources of inspiration.

The Setos research, design and produce 9brand's products at their studio in Kichijoji, Tokyo.

Contact: 9brand
E-mail: seto@9brand.com
Website: www.9brand.com

PAGES 82–83

Pen Tray

## Hiroshi Yamasaki

Yamasaki was born in Hyogo Prefecture in 1970. He graduated from the Art Course of Akashi Senior High School, and went on to study product design at Osaka Municipal College of Design. In his first job, he supervised product development at a stationery manufacturing company, then left in 2000 to establish himself as a freelancer. He is well-known for the wide variety of materials he employs in his work, from plastic and metal to ceramics and Japanese lacquer. In 2005 he founded Yamasaki Design Works where he mainly designs and develops products for everyday use.

Contact: Hiroshi Yamasaki
2-17-6-308 Higashi-nihombashi, Chuo-ku, Tokyo, Japan 103-0004
E-mail: info@ymsk-design.com
Web site: www.ymsk-design.com
For product inquiries: Wajima kirimoto
32 Naritsubo, Sugihira-town, Wajima-shi, Ishikawa, Japan 928-0011
E-mail: houkiji@big.or.jp
Website: www.kirimoto.net

PAGES 84–85

Trash Pot

## Drill Design

Drill Design was formed by the young designers—Yusuke Hayashi, Yoko Yasunishi, and Naomi Hata in June 2000. Centered on product design, Drill Design engages in total design, from graphics and packaging to display spaces, stores and architecture. The objective of the company is to employ flexible ideas to solve problems from various angles, thereby "drilling" to the heart of problems and questions that arise throughout daily life.

Contact: DRILL DESIGN Co.,Ltd.
2-15-10 Mita, Meguro-ku, Tokyo, Japan 153-0062
Tel: +81-3-3792-6950
E-mail: hello@drill-design.com
Website: www.drill-design.com

PAGES 86–87

Riki Stool

## Riki Watanabe    (PAGES 72–73  ALBA/Riki Watanabe Collection)

PAGES 88–89

Animal Rubber Band

## Passkey Design

In 1995, Yumiko Ohashi and Masanori Haneda came together to establish the design unit Passkey Design. From their base in Tokyo, Ohashi and Haneda mainly design industrial products such as domestic appliances for mass production. The principal objective of Passkey Design is to create ultimately usable products, and accordingly great care is taken when designing user interfaces such as screens. The designers also realize the importance of adding an element of fun to their pieces, and it is along these lines that the Animal Rubber Band was conceived. Animal Rubber Band is available for purchase at many museum shops around the world, including that of MoMA.

Contact: Passkey Design
2-26-16-302 Takamatsu-cho, Tachikawa-shi, Tokyo, Japan 190-0011
Tel: +81-42-522-8013
E-mail: passkey_design@nifty.com

## Splash
### Yasuhiro Asano

Asano is an interior and graphic designer working mainly in the field of product design. He is a graduate of the Department of Architecture at Kogakuin University, the Kuwasawa Design School, and the Milan Domus Academy. He established the Asano Design Studio in 1979.

Asano has competed in and won numerous design competitions. The principles of space can be seen everywhere in his designs; he even brought a Mongolian nomad dwelling, known as a Ger, into his office and turned it into a meeting room.

He is a part-time lecturer at Kuwasawa Design School and the Department of Art and Technology at Hosei University.

Contact: Asano Design Studio
7F 8-8-16 Nishi-Gotanda, Shinagawa-ku, Tokyo, Japan 141-0031
TEL: +81-3-3490-8681
FAX: +81-3-3490-9746
E-mail: asano@nisiq.net
For product inquiries: www.plus-d.com

## Aquarium #003
### Shinichi Sumikawa

Sumikawa was born in Tokyo in 1962 and graduated from Chiba University in 1984, after which he worked for Sony as a product designer. In 1987 he moved to the U.S.A. and began working in the Sony America Design Center, where he was engaged in a project to adapt the Sony Walkman for the American market. In 1992, he established Sumikawa Design in Tokyo, and since then has produced a diverse range of products including bathtubs, handicrafts, and IT devices for professionals,. His Supplement Case is available for purchase at MoMa.

He received the Grand Prize at the Toyama Product Design Competition 2005, and is a member of the judging committee of the Good Design Award. He was selected for the 1995, 1997, 1998, 1999, and 2001 International Design Year Book, London.

Contact: Sumikawa Design
1-10-4-110 Nishi-Tsutsujigaoka, Chofu-shi, Tokyo, Japan 182-0006
E-mail: sumikawa@ca2.so-net.ne.jp
Website: www001.upp.so-net.ne.jp/sumikawa/

## The Tsubame
### Eiji Mitooka

Mitooka, a designer and illustrator, was born in Okayama Prefecture in 1947. He began his career in illustratration and from there moved gradually into the fields of graphics, textiles, furniture design, architecture, ship design, and railroad design. Since 1988 he has worked for JR Kyushu as a designer of trains and rural stations.

He has won many national and international awards for his work, including four Brunel Awards in the long- and short-distance passenger train category. He has also received accolades for his graphic designs and uniform designs.

Contact: Don Design Associates
24-11 Nakamaru-cho, Itabashi-ku, Tokyo, Japan 173-0026

## Super Cub

Contact: Honda Motor Co.,Ltd.
www.honda.co.jp/motor-lineup/supercub/index.html

## Prius

Contact: Toyota Motor Corporation
http://toyota.jp/prius

## AQUOS C1
### Toshiyuki Kita

Kita was born in Osaka in 1942. He began his career in Japan and Milan, Italy in 1969. He has produced many best-sellers for Italian, German, and Japanese manufacturers. His pieces have been selected for the permanent collections of museums throughout the world such as the Museum of Modern Art, New York and the Centre Georges Pompidou, Paris.

Contact: STUDIO KITA
2-6-9 Kouraibashi, Chuo-ku, Osaka, Japan 541-0043
E-mail: info@idk-design.co.jp
Website: www.toshiyukikita.com

For product inquiries: www.sharp.co.jp

## ACKNOWLEDGMENTS

The author and publisher would like to give special thanks to all the designers who graciously agreed to share their thoughts and creations on these pages. We also extend our appreciation to the many people and organizations who cooperated in the making of this book:

Canon Inc. (pp. 66–67), Fuefuki-city Board of Education (6), Hakusan Porcelain., Ltd. (44–47), H Concept Co., Ltd. (88–91), Honda Motor Co., Ltd.(98–99), Horizumi (20–22), Kikunoi (23, 79), Koizumi Douguten (36–37), Kyu-Yagishita-tei, Negishi Natsukashi Park (14–15, 28–29, 81), Nichia Corporation (11), Metropolitan Gallery Inc. (41), miyakonjo product (28–30), Ozeki & Co., Ltd. (43), Ricordi& Sfera Co., Ltd. (50–51, 56), Seiko Watch Corporation (72–73), Sharp Corporation (104), Silver Seiko Ltd. (32–33), Sony Corporation (68–69), Suntory Museum of Art (10), TAMU (84–85), Tendo Co., Ltd. (14–16, 40), Tezuka Architects (104), Tofukuji (19), Tokyo National Museum (9), Toyota Motor Corporation (100), Yamagiwa Corporation (24–25, 38, 42), Yoko Furuta (65), YOS Collection (86–87)

## PHOTO, ILLUSTRATION AND LOGO CREDITS

PAGE 6: Kamon Earthenware Vessel, excavated from the Katsurano ruins and dating back to the latter half of the Mid-Jomon Period (Sori style); φ13.1×H23.0 inches (φ33.2×H58.5cm); designated cultural asset of Yamanashi Prefecture. ©Shogakukan Inc.,

9: Kondo Sankosho, 11th Century (Mid-Heian Period), copper plating, length 7.1 inches (18.1cm). Designated as an important cultural property and part of the Gallery of Horyuji Treasures at Tokyo National Museum. IMAGE: TNM Image Archives, Source: http://TnmArchives. jp/

10: Satsuma Kiriko ruby-colored plate, one of a set of three dating from the late Edo Period (1850–68); φ7.2×H1.4 inches (φ18.4×H3.6cm); exhibited at the Suntory Museum of Art.

11: Courtesy of Nichia Corporation

17: Harutaka Nodera. Reprinted from *Confort No.28* published by Kenchiku Shiryo Kenkyusha.

26: Tokujin Yoshioka

32: Sketch by Chiaki Murata

35: Sketches by Katsushi Nagumo

42: © 2006 The Isamu Noguchi Foundation and Garden Museum/ARS, New York/SPDA, Tokyo

51: Sketches by Shin Nishibori

52–53: Sketches by Takashi Ashitomi

57: Yasuo Konishi

61: Yukiko Kuma

71: Sadao Hibi

93: Sketches by Shinichi Sumikawa

94–97: Illustrations and logos by Eiji Mitooka; Photographs by Hiroyuki Okatsugi

98 (LEFT): © Honda Motor Co., Ltd.

100: Courtesy of Toyota Motor Corporation

101: Yasutaka Tanji, Dandy Photo

（英文版）オリジンズ　Origins

2006年11月28日　第1刷発行

| 著　者 | 萩原 修（はぎわらしゅう） |
|---|---|
| 撮　影 | 久間昌史 |
| 翻　訳 | フィリップ・プライス |
| 発行者 | 富田 充 |
| 発行所 | 講談社インターナショナル株式会社 |

〒112-8652　東京都文京区音羽 1-17-14
電話　03-3944-6493（編集部）
　　　03-3944-6492（マーケティング部・業務部）
ホームページ　www.kodansha-intl.com

印刷・製本所　大日本印刷株式会社